IMAGES
of America

McDonald
County

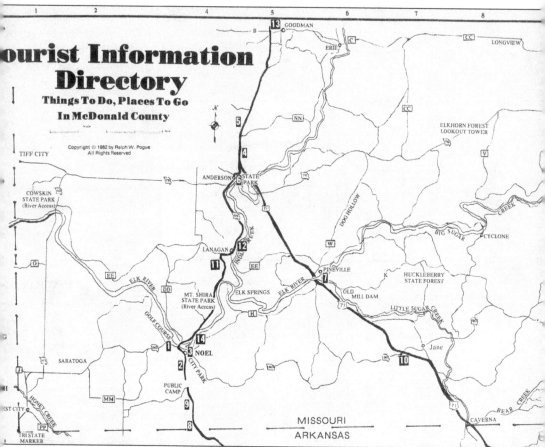

McDonald County, in the extreme southwestern corner of Missouri, borders Oklahoma to the west and Arkansas to the south. A hilly Ozark region first settled in the 1830s, it remains a beautiful rural area with high bluffs and sparkling clear rivers. Three towns—Goodman, Anderson, and Pineville (the county seat)—are on the north/south highway. A fourth town, Southwest City, is in the southwestern corner of the county. (Courtesy of Ralph Pogue.)

ON THE COVER: Strawberries were such a lucrative cash crop from 1900 to 1950 that during this time, the area was the "Strawberry Capital of the World." During strawberry season, McDonald County families, including these residents of Goodman in 1911, picked them all day in the heat. When their wooden carriers were full, the berries were taken to a shed and put into crates. During the season of 1909, the Anderson depot exported 27,850 crates, contributing $56,673 to the local economy. (Courtesy of McDonald County Historical Society.)

IMAGES
of America

McDonald
County

McDonald County Historical Society
Foreword by Al Chapman

ARCADIA
PUBLISHING

Published by Arcadia Publishing
Charleston, South Carolina

Library of Congress Control Number: 2021943580

For all general information, please contact Arcadia Publishing:
Telephone 843-853-2070
Fax 843-853-0044
E-mail sales@arcadiapublishing.com
For customer service and orders:
Toll-Free 1-888-313-2665

Visit us on the Internet at www.arcadiapublishing.com

This book is dedicated to all the people who grew up in McDonald County. They cherish their history and exemplify great Midwestern values of hard work and service to others.

CONTENTS

ACKNOWLEDGMENTS

This book exists due to the fierce loyalty and passion McDonald County people have for cherishing and preserving their heritage. It began in the 1800s with writers James A. Sturges and Claib E. Duval. They were followed by historians Vance Randolph, Ralph and George Pogue, and Pauline Carnell. Many wrote books on county history, including James Sturges, Rose Stauber, Stan Fine, Larry C. Bradley, Kay Hively, Albert E. Brumley Jr., James K. Cadle, Jean Helm, Frankie Carlin Meyer, Joe Taylor, Blanche and Cheryl Cook, Gayle Foster, Karen Jennings, Fran Billings, A.G. Buttram, Dwight Pogue, George Pogue, Ralph Pogue, James Reed, J.E. Cowan, and Don Walker.

Thank you, leaders at the McDonald County Library—Zella Mae Carnell Collie, Retha Mitchell, Velta Strong, and Hazel Sheets—for your dedication to preserving historical documents and sharing them with us. Others, such as Marilyn Carnell, Virginia Hall, Tom Lockhard, Al Chapman, James B. Tatum, Jean Stratton Bird, Ric Akehurst, Al Dixon, Barb Ittner, Bertha Nichols, Kenny Underwood, and Tammy Clark, have been especially helpful. Recently, over 100 families shared photographs. Jo Pearcy, Gene Hall, Kathy Underwood, and Raylene Lamb were leaders in saving buildings and court documents. This book rests on their shoulders.

Since 1963, the historical society has become the glue for collecting, preserving, and celebrating county history. Volunteers work tirelessly, and four sites in the county are listed in the National Register of Historic Places.

Thank you Bill Martin, Paul Lewis, B.J. Goodwin, Arvest Bank, and First Community Bank, who gave financial support for publishing this book.

Those most active in the research and writing process were Sam Alps, Karen Dobbs, Judy Rickett, and Claudine Doherty, along with main writers Phyllis Chancellor, Gayla Baker, and Lynn Tatum. We wish to thank editors Benjamin Holley, Marilyn Carnell, Retha Mitchell, Frankie Meyer, Natalie Alumbaugh, Dwight Pogue, Jack Kellogg, and Ric Akehurst.

Working on the book was a labor of love. We wanted to showcase the family-oriented, caring, hardworking, and multi-faceted individuals who once made McDonald County their home. In a sense, it was they who wrote this history.

Unless otherwise noted, photographs are courtesy of the McDonald County Historical Society.

FOREWORD

The McDonald County Historical Society has brought together a pictorial history of the county provided by the residents of the county. They have, through these pictures and narratives, brought to life a time in history that is relevant to many of the small rural towns throughout the United States. Photography was just becoming available in the mid-1850s, soon after McDonald County was organized in 1849. It is a remarkable achievement that the historical society has been able to bring together such a masterful visual history of McDonald County.

It is of interest that much of this timeframe encompassed the Civil War, the Great Depression, World War I, and World War II, which history has shown to be one of the most significant transformative periods in the United States. McDonald County was clearly a microcosm of all that was happening in the country as clearly reflected in this pictorial history.

More specifically, this book reflects the status of veterans, schools, agriculture, and small-town life. There are a couple of dramatic periods, one reflecting the making of the original Jesse James movie (1938) with Tyrone Power and the second a somewhat tongue-in-cheek secession from the state of Missouri to become the McDonald County Territory (1961). It seems that the state, among other things, left this area out of its tourism brochures, much to its regret.

If you have the luxury of travel, include a trip to Pineville, Missouri, where you will be able to visit the McDonald County Historical Museum, located in a renovated and restored courthouse. You will see, in person, a reflection of the 1850s and beyond through the pictorial and narrative displays throughout the museum.

If you would like to take a virtual trip to visit with any of your own ancestors who may have lived in small-town America, this nostalgic pictorial book will allow you to take that trip.

—Al Chapman

INTRODUCTION

McDonald County is a rural area at the extreme southwestern corner of Missouri. Best known for its beautiful bluffs above crystal-clear rivers in the wooded Ozark hills, it also encompasses a large prairie near Oklahoma. In the 1840s, settlers who came to McDonald County's rocky hills were hard-working, creative people from the Appalachian regions of North Carolina, Tennessee, and Kentucky. The prairie in the far southwestern corner of the county was settled by Southern farmers and businessmen who developed successful trading practices with Native Americans in nearby Indian Territory.

Throughout the hill country, small settlements evolved. Many had a post office along with a general store, a school, and a church. Due to vast distances to any city, folks had to take care of their own problems or find help from a neighbor. Outsiders were welcome if they had the same values, but those seeking mischief could meet up with a gun. The same rural qualities that attracted honest, hardworking families also brought bushwhackers and outlaws. Frontier justice, imposed by citizens without official authority, was often the only way for fledgling communities to survive.

The inhabitants created a culture of self-sufficiency. People remained isolated for many years and were steadfast in their ways. They grew their own food, made their own tools, and created their own music. Most everyone had a garden, a cow, chickens, small crops, and a horse or a mule. Women knew how to make a pie from scratch. They also knew how to smoke, pickle, can, boil, and dry food. Cold springs provided refrigeration. Yarn was spun from the sheep and goats they raised. Clothes were homemade on treadle sewing machines, and quilting provided blankets and an opportunity for women to socialize. Men hunted possums, coons, rabbits, deer, ducks, quails, wild turkeys, and many of the other small animals roaming the woodlands. Mules were used to clear the land so that homes and barns could be built and crops planted.

Travel was difficult for everyone well into the 1900s. Roads were carved into the hills, but remained dirt and thus were often muddy. Low-water bridges, impassable when the water was up, were built at fords. Many one-room schools had to be built—records show more than 75—to give children access to a teacher within walking distance of home. Schools were made of local materials: stone, rocks, logs, cut timbers, and later, brick. Most had a bank of large windows facing south to take advantage of the light and warmth of the sun in the fall and spring. Wood stoves were used for heat in the winter. Beginning in the late 1950s, a traveling bookmobile from the public library was a popular addition to the rural experience. It provided a way to expand the minds and imaginations of children and adults alike who looked forward to its arrival with eager anticipation. As roads and transportation improved, schools were consolidated, and most of the one-room schools, no longer needed, collapsed into the landscape.

While most small settlements vanished over time, some thrived and grew into towns. After county boundaries were established in 1849, and Pineville was finally selected as the county seat in 1857, it began to grow in population. When the Kansas City Southern Railroad was built through the area in 1891, settlements near the tracks such as Goodman grew, while Noel developed into

a tourist destination. Anderson was not found on maps before 1891, but soon after the railroad was built, that area became a strong commercial center. After the Civil War, the trading center of Honey Creek Town likewise grew rapidly due to fertile farmland and savvy businessmen. It thrived, was platted, and was renamed Southwest City.

Farmers began to find commercial benefit from the railroad. From 1900 to 1950, strawberries, which grew well here, became a lucrative cash crop. During those years, boxcars carrying thousands of strawberry crates rumbled out of Goodman, Anderson, Noel, and Lanagan every day for three weeks. During the harvest, families and migrant workers worked long days in the fields. McDonald County's Aroma strawberries were delivered across the country and even into Canada.

McDonald County evolved as a tourist destination and was advertised as the "Land of a Million Smiles" because of its wooded hills, beautiful bluffs, winding roads, and crystal-clear rivers. Cabins were built and rented, caves were opened for tours, and great meals were served in roadside cafés. Soon after the tracks were laid by the Kansas City Southern, railroad executives started coming. They built a grand hotel and resort on the Elk River near Lanagan and called it Ginger Blue. The Cove, Riverside Inn, and other cafés served Southern fried chicken dinners that locals and tourists from as far away as Tulsa enjoyed on Sunday after church. Highways built under high bluffs created picturesque postcards that were used for writing proverbial "wish you were here" messages to friends and families nationwide. Today, the county continues to enjoy a lucrative tourism industry.

In 1938, the beauty of the area brought 20th Century Fox to McDonald County to film *Jesse James*, starring Henry Fonda and Tyrone Power. Director Henry King looked throughout Missouri for a location after finding Liberty, Missouri, the normal setting for the plot, too commercial. The Pineville area was selected for its quaint look. It had an 1870s courthouse, dirt roads, old farmhouses, caves, bluffs, and wooded hills. The film company spent about $250,000 during six weeks of shooting, which brought a significant economic boon to the area. It purchased lumber, paid carpenters, hired horses and buggy drivers, paid over 200 local people as extras, and hired cooks to feed cast and crew. An equal amount of money came into the Depression-worn county from thousands of visitors attracted by the film. Residents made money cooking for visitors, parking cars, renting rooms, and in all ways helping them to feel welcomed and comfortable. The event is commemorated today with Jesse James Road in Pineville and the annual four-day celebration Jesse James Days.

In 1961, the tourism trade seemed threatened when the state highway department left eight McDonald County towns off its *Family Vacationland* map. Locals were shocked, and when county officials asked the reason for the omission, the department claimed the area was "too commercial." This outrageous news sparked the most successful tongue-in-cheek secession movement ever created. A formal declaration of secession (Senate Resolution Number 51) was submitted on the senate floor at the state capitol in Jefferson City. It resolved that McDonald County would combine with Benton County, Arkansas, and Delaware County, Oklahoma, to become the 51st state. Ralph Pogue, the newly elected territorial press secretary, saw to it that the news was reported on the Associated Press and United Press International wires, and the story received nationwide attention. Territorial stamps and passports were created. Officers were elected, as was a 300-strong territory militia with men dressed in hillbilly attire and sporting muzzle-loading guns and powder horns. The militia's "border patrol" handed out visas to visitors and vacationers to the new territory. Headlines about the secession appeared across America. Tourists came in droves, making the secession movement more successful in attracting visitors than any map could have been.

Artists and musicians love this beautiful backcountry. Albert E. Brumley, country songwriting legend who wrote "I'll Fly Away" and "Turn the Radio On," came here from Oklahoma as a young man and stayed to write and raise his family. His descendants continue with his publishing house in Powell. National champion fiddlers were raised here, too. Today, Doug Hall, one of many artists who live here, has built his own log cabin and studio in the woods. He is self-taught yet phenomenally successful.

To celebrate this rich and unique heritage, the McDonald County Historical Society restored the old courthouse and created an award-winning history museum. When it opened in 2013, docents reported that the military exhibits and the special veterans exhibit were the highlight of tours. An abiding love of country was long established. Most early families had husbands and sons who fought and died on both sides during the Civil War. Descendants of those settlers continued to serve over the years. Many were wounded or killed in action during World War I, World War II, the Korean War, and the Vietnam War. The courtroom walls are now covered with 113 large, framed photographs of McDonald County veterans. Visitors leave with a deepened respect for the sacrifices made by the men and women of McDonald County.

Today, the people of McDonald County have a strong interest in preserving their history and culture. The towns of Jane, Goodman, Anderson, Southwest City, and Pineville all hold annual festivals to celebrate days gone by. Residents are eager to pass on the skills of their ancestors along with their values of placing God at the center of their lives and holding fast to their families. On Thanksgiving Day, homes are filled with several generations of extended family, and many platters of home-cooked food are shared, with lots of love to go around. Neighbors take care of neighbors. People are honest, strong, and friendly. Descendants of early settlers still live here for good reasons. The two largest volunteer organizations in the county are the Young Outdoorsmen and the historical society. The county's children learn how to hunt and handle themselves in the woods, while elders preserve the history and the culture that is deeply rooted here.

Old Midwestern and Ozark values—work hard, live close to the land, support neighbors in need, stay close to family, put God at the center of life, and serve when called—survive in McDonald County, shaping the character of its people today.

One

BYGONE DAYS

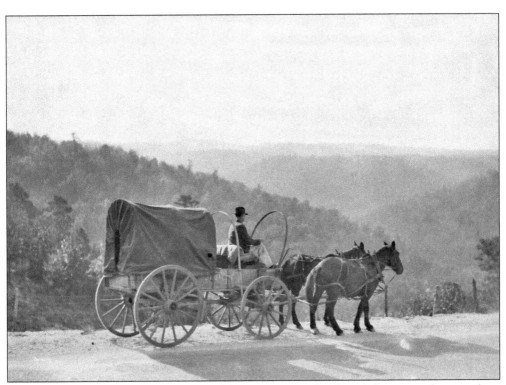

In 1932, Lewis Kelley, conductor of an old-time singing school, took his covered wagon from Cyclone to Eureka Springs in northwest Arkansas. The bygone days of McDonald County vanished into a rich and unique past. Yet in this isolated part of the Ozarks, days of hard physical work balanced with simple pleasures, such as singings and pie suppers, continued well into the 1900s. This photograph is one of many taken by Vance Randolph, Ozark author and folklorist. (Courtesy of Lyons Memorial Library, College of the Ozarks.)

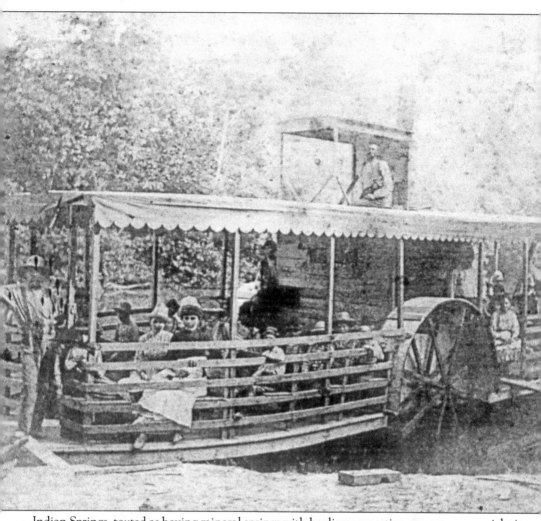

Indian Springs, touted as having mineral springs with healing properties, sprang up overnight in the 1880s but was gone in nine years. It once bustled with 2,000 people and had general stores, blacksmiths, wagon makers, a flour mill, sawmills, lawyers, doctors, and three hotels. A favorite attraction was the first and only side-paddle steamboat in the county, which floated on a lake made by a dam above the town. It seated 75, and for 10¢, passengers could enjoy a 20-minute tour on the water.

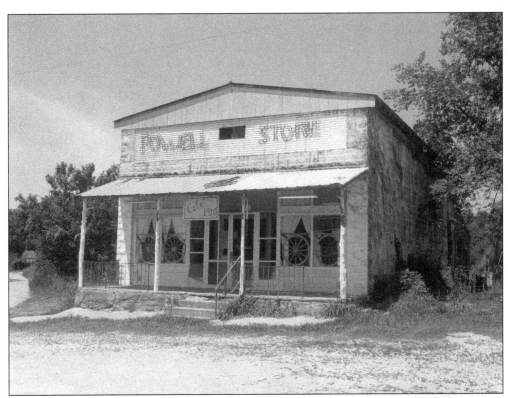

The Powell Store still stands as a testament to the building skills of long ago. The bridge at this early settlement carried traffic over Big Sugar Creek in eastern McDonald County for over 95 years. Built in 1914 at a cost of $4,000, the bridge is distinguished among other examples of truss bridges built during that time for its relatively long span, well-preserved condition, and excellent documentation. It is also unique because it is one of only a few roadway bridges combining through and pony truss spans. Listed in the National Register of Historic Places, it is currently owned and maintained by the Powell Historical Preservation Society and is open to pedestrian traffic only. (Right, courtesy of the Powell Historical Preservation Society.)

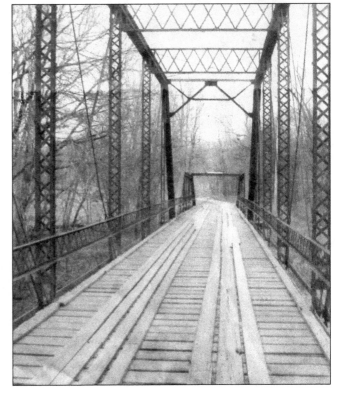

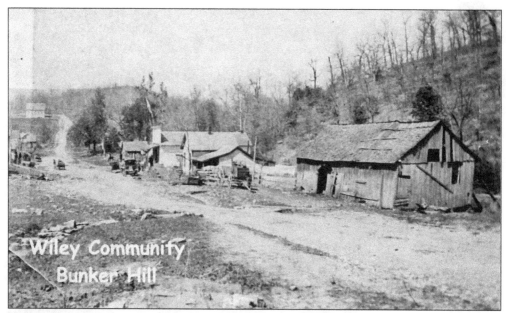

Wylie, a frontier settlement, was north of Pineville on Dog Hollow Road, now known as Highway W. The post office, established in February 1894 by Zechariah Baker, was discontinued in May 1909.

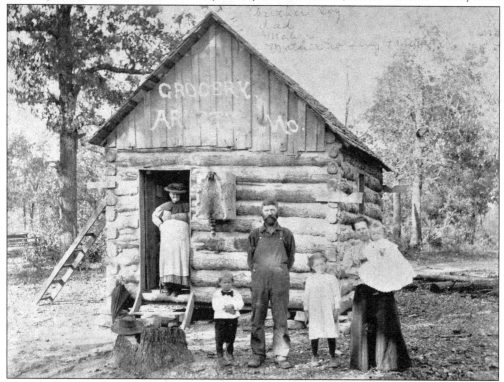

In 1910, Sarah Akehurst stands in the doorway of the Arnett Grocery Store, where Jackson Cook later established a post office in 1916. John Rue Akehurst is standing in the center with his wife, Lula, and children (from left to right) Roy, Mable, and Frank. The community of Arnett was named after Tol Arnett, who lived in that area of southeastern McDonald County.

James Willard Holland stands with his dog in front of the livery stable on the main street of Jane in this photograph looking east. Two stores and the white framed school just west of the cemetery are in the distance.

White Rock Prairie had a post office when the county was organized in 1849, but it did not survive the Civil War. Samuel Ross re-established a post office there in 1882 under the name of Jane, in honor of his daughter Janie. It operated until 1966 and has now been restored, standing as a celebration of days gone by. (Courtesy of Lyons Memorial Library, College of the Ozarks.)

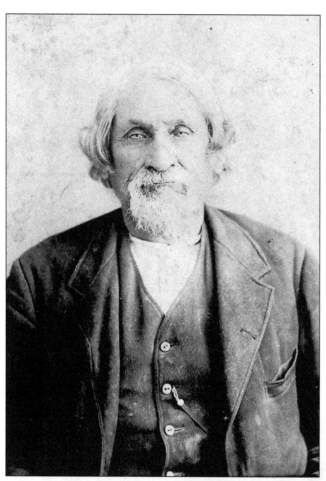

Chief Mathias Splitlog, millionaire of Wyandotte and Cayuga heritage, was born in Canada in 1821. He was a mechanical genius and became a successful entrepreneur. Around 1874, he and his wife, Eliza, moved to the Seneca Cayuga Reservation in Indian Territory. They developed a farm, founded the town of Cayuga, and built a magnificent church. When the Benna mine in southwest Missouri reported rich ore, the Splitlogs bought land in that area, founded Splitlog City, started a mining company, established the Occidental Hotel, and built a railroad from Joplin to his city. On learning that Benna's ore mine was a scam, the Splitlogs sold their railroad at a loss so they could reimburse investors. Later, his railroad became part of the intercontinental Canadian Pacific Kansas City Railroad. In 1893, Mathias Splitlog was elected chief of the Seneca Cayuga Nation.

Country songs tell stories and entertain. This was especially true in the Ozark hills. In 1928, Judy Jane Whittaker of Anderson was known for singing the old ballads. (Courtesy of Lyons Memorial Library, College of the Ozarks.)

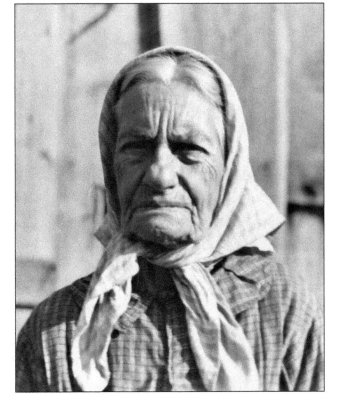

"Ain't No Bugs on Me," "Black-Eyed Susan," and "Ducks on the Mill Pond" are only a few of the songs one might hear from Malinda Ellen Hopper Bullard of Pineville. Linnie Bullard recorded songs for Vance Randolph that are now housed in the Library of Congress. She was known as the "Songbird of the Ozarks." (Courtesy of Lyons Memorial Library, College of the Ozarks.)

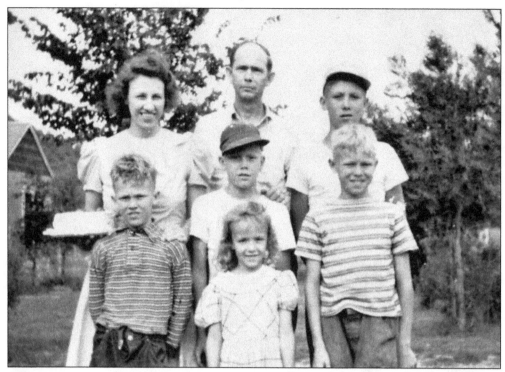

Pictured above around 1945, country songwriting legend Albert E. Brumley stands in the back row with his wife, Goldie, and Albert E. Brumley Jr. Their other sons (from left to right) Jack, Tom, and Bob are in the middle row, with daughter Betty in front. Brumley moved to McDonald County from Oklahoma as a young man and remained here to raise his family and write songs. He held singing schools in Pineville and was a wonderful pianist and songwriter. Before television, singing schools provided popular entertainment. According to *Billboard* magazine, 330,000 copies of his songbook of radio favorites were sold in 1952. Brumley's song "I'll Fly Away" is the most recorded song in the history of American music. His first song, "I Can Hear Them Singing Over There," and other favorites like "Turn Your Radio On" and "I'll Meet You in the Morning" have endured as classics. The Albert E. Brumley and Sons/Hartford Music Company has operated in Powell since the 1940s.

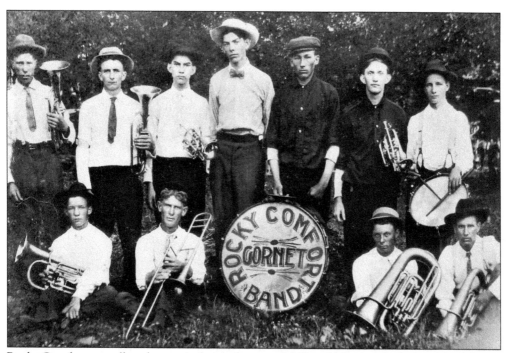

Rocky Comfort, a small settlement in far northeastern McDonald County, had a band (as did most towns) that played at social gatherings such as Fourth of July celebrations. This cornet band had nine young men on horns and two drummers. Green Beaty, at center in the back row wearing a bow tie, later became the first train station agent at the Wheaton depot in 1908.

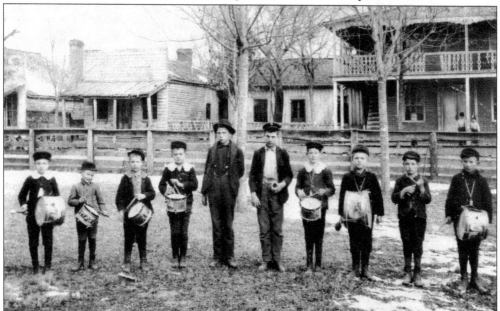

On the north side of the Pineville courthouse square in 1894, young members of a rhythm band stand ready to play. From left to right are Claude Duvall, Everett Shields, Charles Walters, Everett Manning, Floyd Barr, Clarence Duvall, Charles Johnson, Wallace Swansen, John Johnson, and Floyd Shields. On the porch of the Ware Hotel across the street are Vera and Henry Ware.

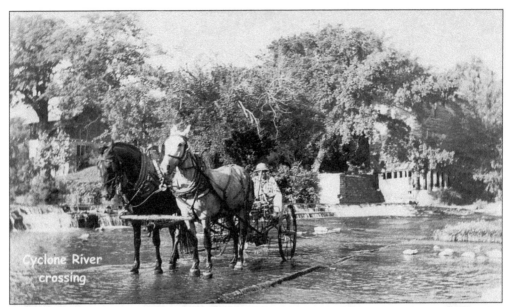

Cyclone River crossing

A horse and buggy cross Big Sugar Creek on a low-water bridge at Cyclone, northeast of Pineville. Although bridges were critical to the development of the county, construction was slow due to the high cost. Many low-water bridges in the county, including this one, remained in use into the 21st century.

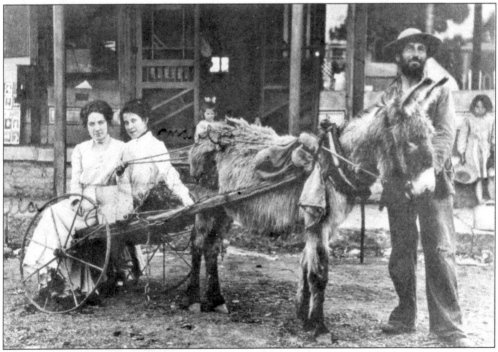

Mr. Foote walked eight miles from his home near Cyclone with his burro and cart to trade in Pineville. On this day in 1912, he posed with Willa Edge and Mabel Coombes in front of Lamb's grocery store on the Pineville square.

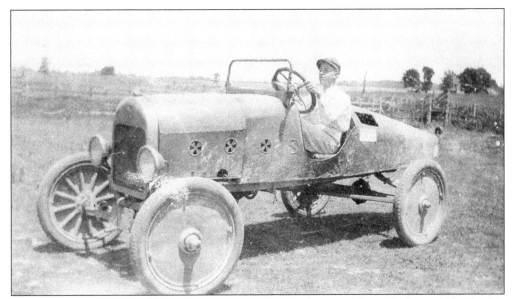

The transition to motorized horsepower was slow. Dirt roads were rocky and often muddy. Readily accessible farm horses and mules were more suitable to traveling the hilly terrain until the roads were improved. In 1929, young Claude Utter used his resourcefulness and mechanical ability to build his own roadster, largely from materials found on his family farm near Rocky Comfort.

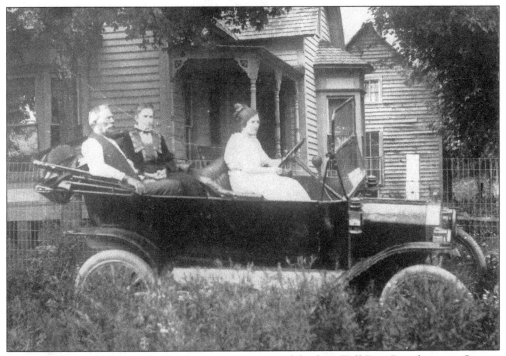

In 1911, McDonald County had only two cars registered, both in Tiff City. Proud owners George and Laura Epperson sit in the back, while Laura's niece Belva Brady is behind the wheel.

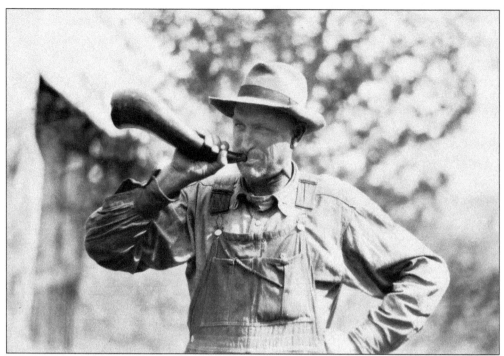

Roy DeAtley puts the call to his hounds at a Pineville fox hunt in 1929. (Courtesy of Lyons Memorial Library, College of the Ozarks.)

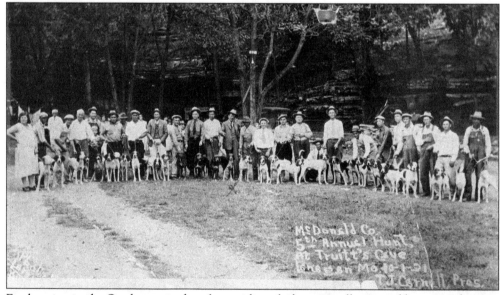

Fox hunting in the Ozarks required no fancy riding clothes, no well-groomed horses, and no cry of "tally-ho." Eager, barking hounds wait as members of the McDonald County Coonhunters Association gather at Truitt's Cave with their dogs in 1931. The hounds were valuable due to their stamina, voice, and ability to stay on track. These Ozark mountain men include S.W. King, Pearly Bone and his son Robert, Roy Rickman, Dewey Edmonds, Roy DeAtley, Floyd Fine, Tom Walker, Tom Carnell (president), Gay Price, Loy Mahan, Bill Keenan, Oscar Bonebrake, and Finis Browder.

Two

FRONTIER JUSTICE

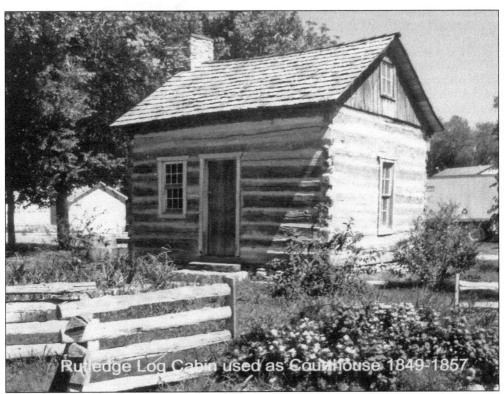

Rutledge Log Cabin used as Courthouse 1849-1857

This old log cabin, built in the town of Rutledge, served as the first official courthouse in McDonald County when the county was formed in 1849. Nearby Maryville, later renamed Pineville, established a rival government. For the next eight years, these two towns fought over the location of the county seat. After three men were killed in a saloon shootout over this fierce difference of opinion, the state stepped in and granted Pineville the honor, as it was most centrally located.

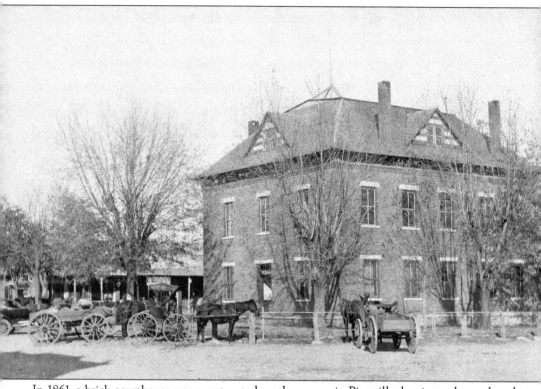

In 1861, a brick courthouse was constructed on the square in Pineville, but it was burned to the ground by bushwhackers just two years later, and all records were destroyed. After the Civil War, a new brick four-square building was erected and opened in 1871. It changed little over time except for a two-story brick addition on the east side in 1909 and a one-story south side addition in 1943, when the entire building was covered in stucco. In 1978, an entirely new courthouse was built a block away. The old courthouse is listed in the National Register of Historic Places and now houses an award-winning county history museum.

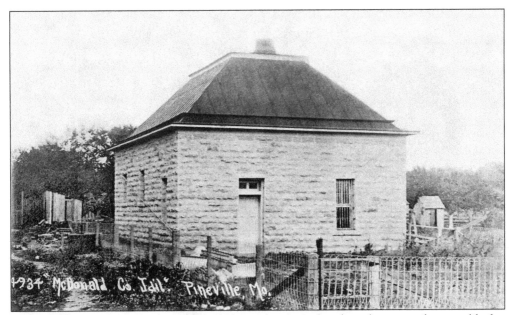

This old county jail, just southeast of the old courthouse, replaced a rudimentary dungeon-like log structure that was accessible only from the roof. When completed in 1904, the local newspaper editor called it "the best in southwestern Missouri." The 18-inch-thick rustic stone walls, steel-barred windows, and secure door were impressive. The jail remained in use until 1992, and it was listed in the National Register of Historic Places in 2020.

Joseph H. Edwards served as the county sheriff from 1900 to 1902. His property south of the jail was later purchased by the county. This provided a convenient location for each sheriff to feed and care for prisoners during his term of office. Today, the sheriff's house has been restored and is owned by the historical society and used as its headquarters.

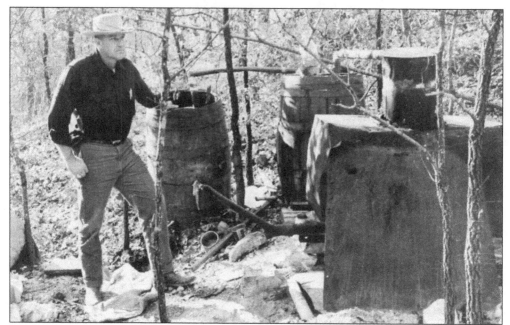

Sheriff Earl Spears looks over an illicit still in 1965. Hill-country stills have been part of the culture since pioneers first settled here. This was probably due to the difficulty of navigating mountain roads, people living far apart, and because several valuable gallons of whiskey could be made from a bushel of corn. To avoid taxes on whiskey during and after the Civil War, local stills became even more profitable. Most local sheriffs agreed with the farmers that it was not wrong, just against the law.

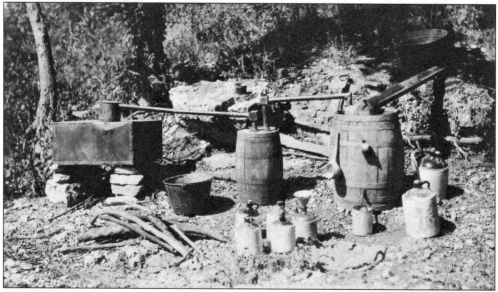

In 1928, Vance Randolph constructed a typical still near his home in Pineville. Corn mash was mixed with sugar, water, and a little yeast. Left to ferment, it was all placed in a copper kettle set on rocks so a fire could be made below. Steam went through pipes, and when cooled, distilled alcohol was poured into jugs as corn whiskey. (Courtesy of Lyons Memorial Library, College of the Ozarks.)

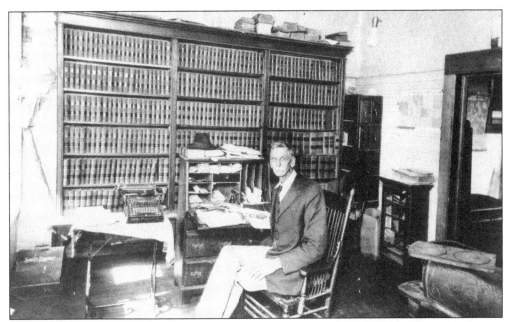

James A. Sturges is best known as the author of a detailed and entertaining history of McDonald County published in 1897, but he was also a busy and successful defense attorney who worked on several historic county criminal cases. He served as postmaster, presiding county commissioner, and school board member, and owned the Sturges Opera House, which was used for community theater and visiting vaudeville acts. He purchased this prized Smith Premiere typewriter in 1905.

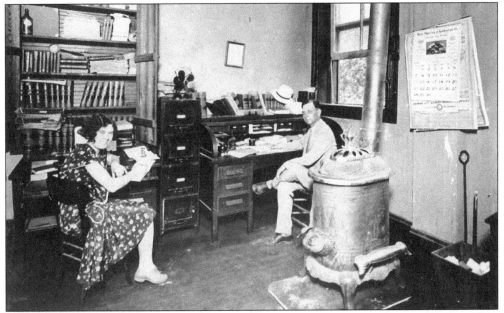

James Marshall Tatum, two-term county prosecutor, sits in his courthouse office with his assistant Miss Elliff in 1931. As a state legislator, World War I veteran, Jersey cow breeder, and long-time defense attorney, Tatum often spoke at graduations and political gatherings due to his quick wit, down-home humor, and eloquent style. His office, seen here, was replicated in the old county courthouse museum.

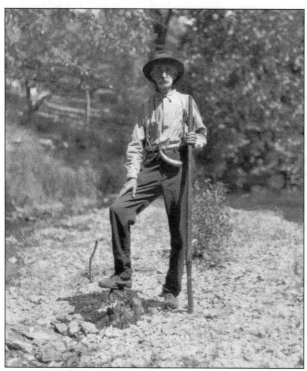

Samuel David MacDaniel probably wore a suit and tie when he was in Jefferson City as a Missouri state representative from 1924 to 1926. Here, near his home in Jane in southern McDonald County, he looks more at ease down by the creek with his muzzleloader and powder horn. MacDaniel was born in 1861 and married Victoria Pierce in 1907. While serving in the 53rd General Assembly, he was on many committees, including one called Local Hills and Miscellaneous. (Courtesy of Lyons Memorial Library, College of the Ozarks.)

A law officer stops for a cool drink at Beaver Springs near Anderson. The water was once thought to have medicinal qualities and attracted not only thirsty travelers but also those seeking treatment for their ailments. Some settled here believing that the area would support a strong economy due to its healing waters.

Everett (left) and Floyd Shields, sons of prominent citizen J.W. Shields, are shown with their guns and dog in 1895. Due to the keen interest in hunting for deer, wild turkeys, squirrels, coons, and other small animals, children in the county were at ease with rifles and guns.

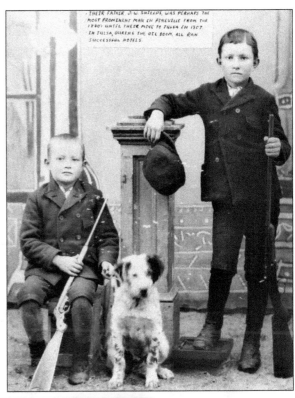

THEIR FATHER J.W. SHIELDS, WAS PERHAPS THE MOST PROMINENT MAN IN PINEVILLE FROM THE 1890s UNTIL THEIR MOVE TO TULSA IN 1907. IN TULSA, DURING THE OIL BOOM, ALL RAN SUCCESSFUL HOTELS.

Young boys were especially vulnerable to gun accidents. In November 1907, Otto Waters, right, accidently shot and almost killed his brother Eugene with a 12-gauge shotgun while hunting. They both lived to old age.

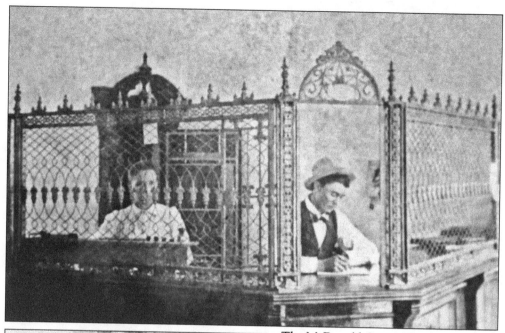

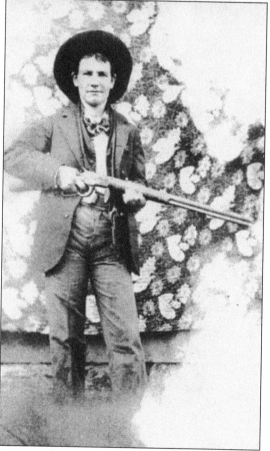

The McDonald County Bank in Pineville was established in 1877 and was guided through the Great Depression by Jasper Armstrong and Arthur Smith. Armstrong family members continued to manage the bank until recently. In 1899, cashiers Lutie Shields (left) and Dell Noel are busy at work. Female outlaw Cora Hubbard and her gang successfully robbed this bank on August 17, 1897. Hubbard, Wilt Tennison, and John Scheetz believed the bank held between $50,000 and $60,000 in cash but left with only $580.

It took the posse only five days to recover most of the money, find all three outlaws including Cora Hubbard, and bring them back for trial. It was believed that Hubbard was the brains of the outfit, and that plans had been made for other such capers. She was sentenced to 12 years in the state penitentiary but was released after seven. The local newspaper described her as "a soiled dove."

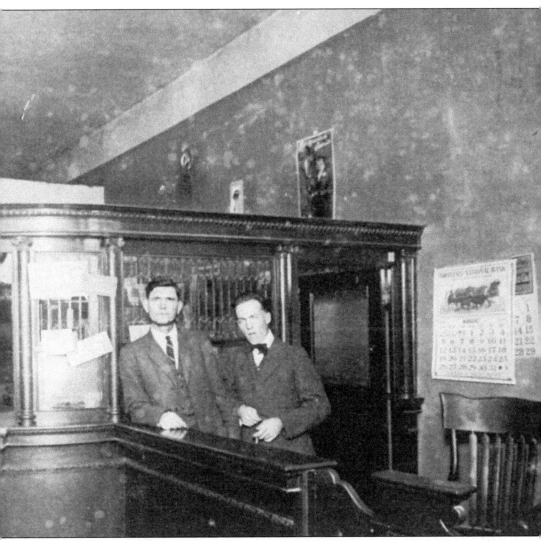

The People's Bank at Southwest City is shown here around 1906, with George A. Cates, cashier (left), and W.F. Stevenson, a director of the bank. Banks in this frontier town were especially vulnerable to robberies due to its border with Indian Territory. In 1894, Bill Doolin's gang of seven came into town to rob the People's Bank. When the outlaws tried to scare the citizens off the streets, the people ran to find safety, and their guns. These citizens killed one gang member and wounded others as the gang rode out of town. However, in the exchange of gunfire, the gang shot and killed auctioneer and former state senator J.C. Seabourne and severely wounded two other townspeople. Within a couple of years, five gang members had been killed by a US marshal, and one went to prison for the bloody robbery. In 1927, the People's Bank was liquidated and purchased by Cornerstone Bank.

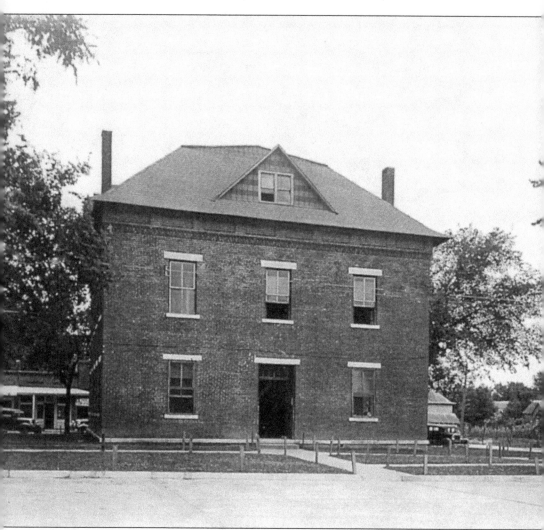

The county did bring a modern law enforcement system into existence by the time this photograph of the courthouse was taken in 1938. But during the early days, citizens took it upon themselves to personally administer what they considered to be justice. For example, in 1883, a beloved and highly respected citizen, Dr. A.W. Chenoweth, was ambushed and killed by his longtime enemy Garland Mann. Despite three trials over a period of two years, a jury still had not returned a verdict. Therefore, a mob took things into its own hands. Over 100 men broke into Mann's Neosho jail cell and fatally shot him. No one was ever arrested for the killing. On another occasion, after Irwin Grubbs robbed and killed a mute man near Powell and had still not gone to trial after six months, a mob overpowered Deputy W.W. Bacon and took Grubbs from the dungeon-like county jail. He was hanged from a tree where the road turned east north of Pineville. Over time, proper law enforcement unfolded with powerful prosecutors and defense attorneys, up-to-date jails, and an evolving criminal justice system. Frontier justice became a thing of the past. However, the detailed and accurate 1897 *History of McDonald Country* reads like a book from the Wild West.

Three

LIVING OFF THE LAND

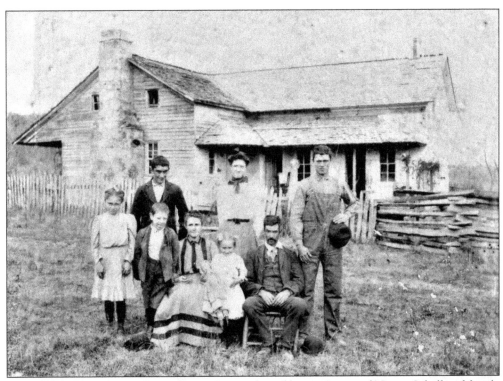

McDonald County has it all: fruit, crops, livestock, and honey. Jesse and Nancy Schell and family are pictured in 1907 in front of their home in Mountain Township where Jesse was born. From left to right are (first row) Ella, Bethel, Nancy, the small child Ester, and Jesse; (second row) Herschel, Ethel, and Virgil. They were typical of hard-working, self-sufficient, and innovative families bound together with a sense of purpose and accomplishment.

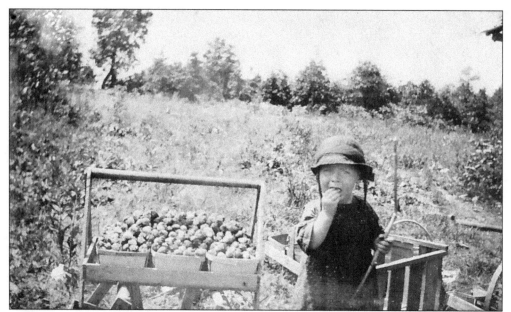

Those strawberries were mighty tempting for this youngster pictured in 1919 at the G.L. Dobbs farm. Around the turn of the 20th century, strawberries became a local cash crop. Aroma brand was the most common variety because the plants were tough and produced berries that were sweet and shipped well. It was developed by the Wild Nursery in nearby Sarcoxie and named after Aroma McNally, daughter of a nursery worker.

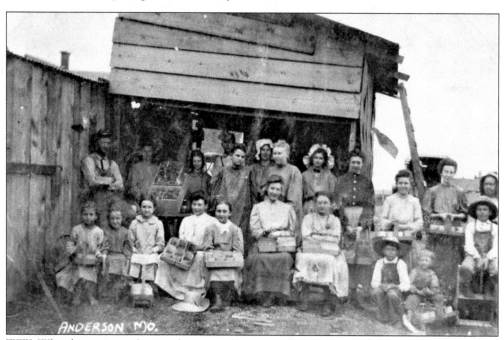

W.W. Whitaker, owner of a strawberry patch near Anderson, reported the value of one acre of strawberries in 1919 to be $1,817.85. Planting and picking were called "stoop" labor, as the berries grew close to the ground. At one time, Anderson advertised needing 1,000 pickers, and the area was called the "Strawberry Capital of the World."

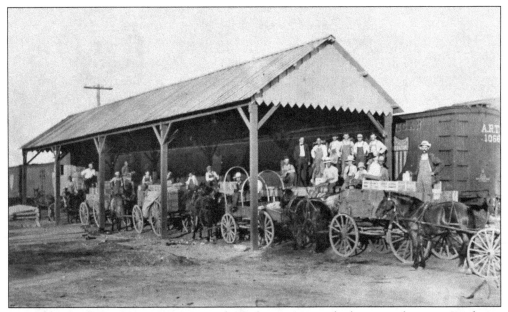

Late in the day, horse-drawn wagons carried strawberry crates to sheds at train depots in Goodman, Anderson, Lanagan, Noel, and Southwest City. There, the berries were inspected, counted, packed into boxcars with ice and sawdust, and sent nationwide. Some even went to Canada. This photograph was taken at the Goodman berry shed. Fred Gasser is standing in the back of the first wagon.

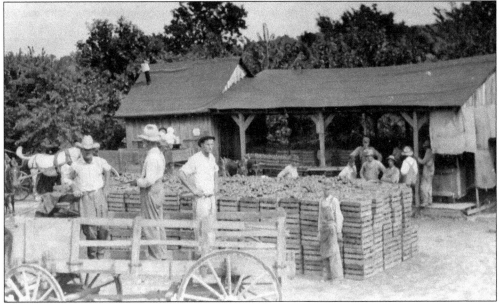

In Anderson, crates were stacked at the farm and then loaded onto wagons to be taken to the depot. In 1922, a record number of strawberries were sent by rail across the nation. Strawberries provided abundant employment and happy farmers, as well as jam and flavorful desserts on family tables. World War II brought sugar rationing and a shortage of labor. Some strawberry farms in the area did not recover, but the berry continued to be a cash crop. In the 1950s, schools let out early so kids could pick strawberries.

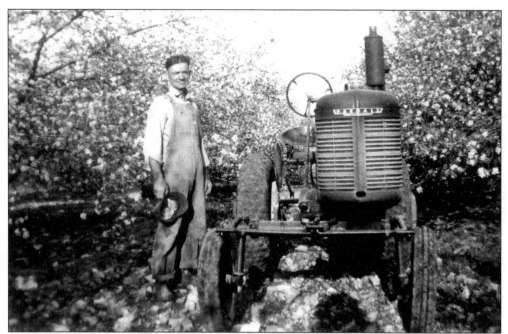

In 1940, Earl F. Stratton stands in his apple orchard near Anderson. In the fall, his tractor pulled a trailer that held 40 bushels of apples, which were taken to the barn to be sorted. The perfect ones were packed for the nearby Joplin Market. In the spring, his vast orchards were such a magnificent sea of white blossoms that cars would stop so people could take pictures. Orchards were found all over the county. An apple from Noel won the state fair prize for best in quality and size. (Courtesy of Jean Stratton Bird.)

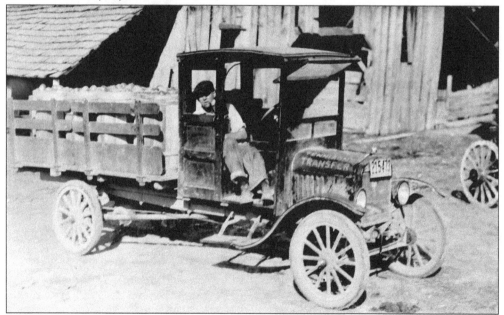

A Tennison Transfer driver sits in an early version of the ever-popular farm pickup truck. His load of apples was picked in the large orchards around Anderson. The Joplin Market may have been the destination for this truckload.

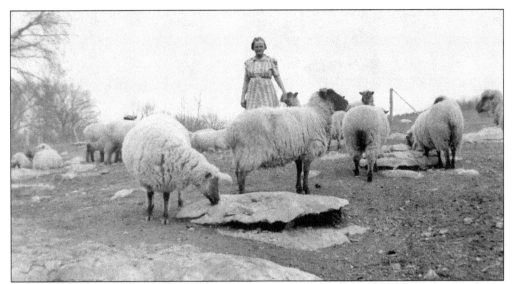

In 1930, Nora Coffee inspects her sheep at the family farm in Bear Hollow south of Jane. Hice and Nora Coffee, with their 12 children, raised sheep, cattle, hogs, and chickens. The sheep had to be penned at the barn every night due to the danger from wild animals.

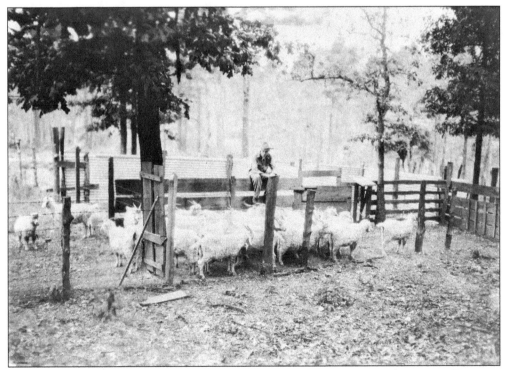

Running sheep through a maze helped the farmer to check for injuries and parasites. (Courtesy of Lyons Memorial Library, College of the Ozarks.)

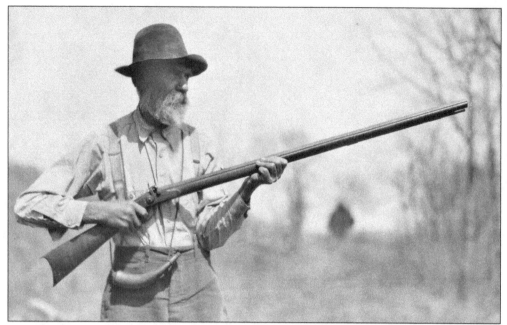

In 1928, Edward Wall of Pineville sold his cabin and 100 beehives to author Vance Randolph, who later documented Ozark culture in several of his books. Wall was an expert hunter, trapper, and storyteller. (Courtesy of Lyons Memorial Library, College of the Ozarks.)

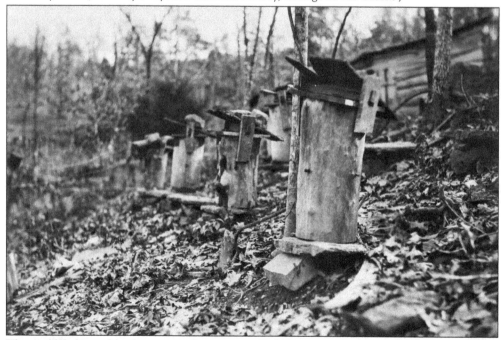

These old-fashioned beehives near Jane were called "bee gums," a hollowed-out log in which bees can make their nests. The name comes from the black gum tree. These native trees and the abundant wildflowers in McDonald County were perfect for producing excellent flavored honey used as a sweetening with an indefinite shelf life. (Courtesy of Lyons Memorial Library, College of the Ozarks.)

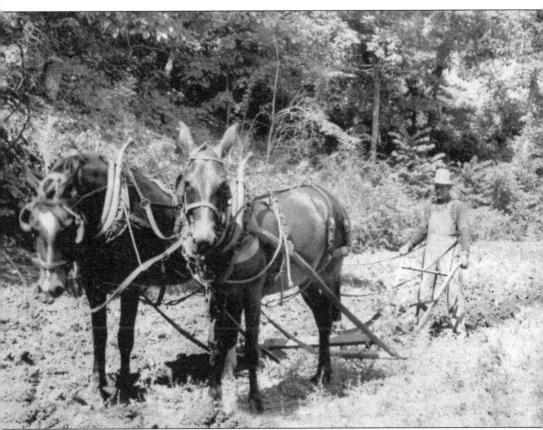

Jake Schell from White Oak Hollow shows that men and mules make a great team on the farm. Mules' hooves are harder than horses' hooves, making them less likely to split or crack and more able to withstand the rocky farm soil found in McDonald County. Mules are hardier, eat less, and live longer than horses. An advertisement in a county paper for a "Jack" in 1937 read, "I have on my farm, two-and one-half miles north of Anderson, John a black Mammoth Jack, six years old, and sixteen hands high who will stand this coming season. Service is $8.00." Harry S. Truman said, "My favorite horse is the mule. He has more horse sense than a horse. He knows when to stop eating and he knows when to stop working." Missouri mules were made famous by the US Army, which purchased many and used them for pulling heavy artillery. Several McDonald County farmers bred these strong, sturdy animals and sent them by rail to Kansas City.

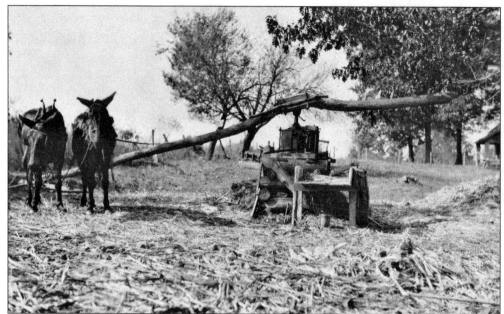

Horses or mules were used to turn the sorghum mill press. In mid-October 1929, farmers near Pineville prepared a field of sorghum for the press and boiling vat to make sorghum molasses. It was a long day of hard work but considered well worth the labor when the sorghum was later drizzled over hot biscuits smothered in butter or used in making popcorn balls. (Courtesy of Lyons Memorial Library, College of the Ozarks.)

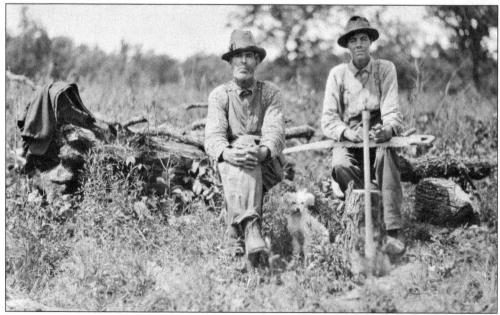

Land needed to be cleared for planting and for pasture. McDonald County men were up for the challenge with their crosscut saws and axes. These two woodcutters are taking a rest near Pack, a small settlement in the southwestern corner of the county. There was an abundance of oak, cherry, hickory, walnut, sycamore, and pine trees for building homes, making furniture, cooking, and heating. (Courtesy of Lyons Memorial Library, College of the Ozarks.)

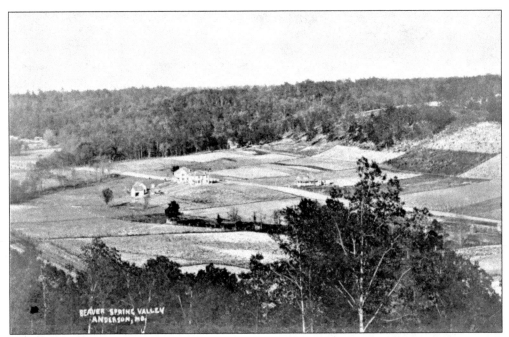

In the fertile valleys, hay was grown, cut, and bundled for winter feed. Using horses and manpower, farmers worked long hard days to get hay out of the field and into the barn.

Haystacks near Pineville are ready to be moved to the barn. Lush, river-valley soil grew quality wheat that was highly valued.

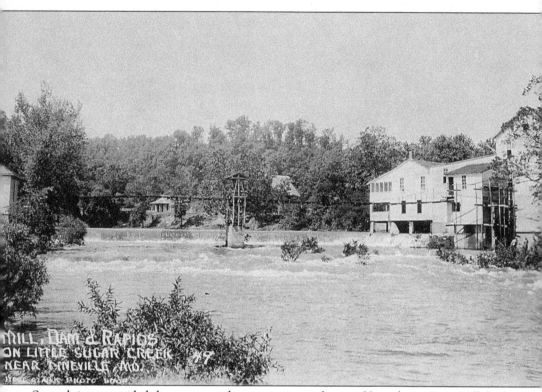

MILL, DAM & RAPIDS
ON LITTLE SUGAR CREEK #9
NEAR PINEVILLE, MO.

Several rivers provided the county with a great source of power. Havenhurst Grist Mill, built in the 1840s on Little Sugar Creek near Pineville, was one of many. Ground cornmeal and whole wheat flour were produced. A swinging bridge that spanned Little Sugar Creek just above the dam led to a generating plant that once supplied electricity not only for the little village of Havenhurst but also for neighboring Pineville. Old-timers recall that the power was turned off at 10:00 nightly by owner H.B. "Guy" Bosserman in 1949. Next to the mill was an icehouse. An ice cream parlor was added in the late 1930s by Fenton Ressler, with all the ice cream made with Ressler's special recipes. The most popular flavors were huckleberry, lemon, and blackberry. The north section of the mill later burned, but many successful eateries have been located in what remains of this once-productive mill that operated for over 100 years.

Four

EARLY SCHOOLS

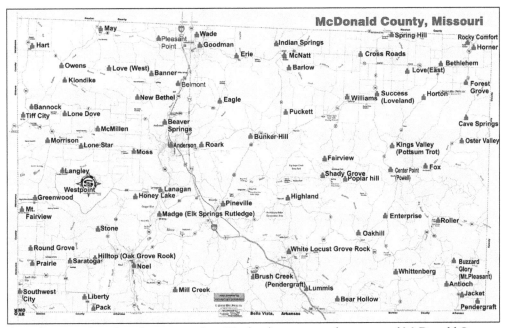

Over the years, there have been more than 75 schools serving students in rural McDonald County, as illustrated on this map. Log, frame, and stone buildings dotted the county, serving as schools as well as community centers and sometimes churches. Most families lived within three to five miles of a schoolhouse.

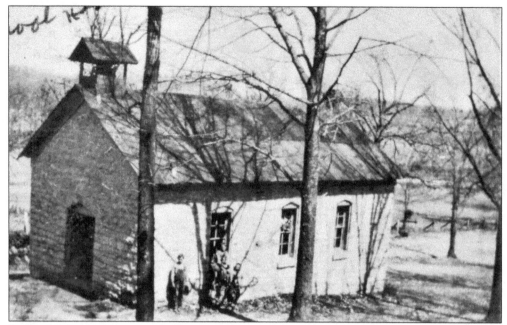

Early schools were constructed of logs, wooden planks, fieldstone, and brick. Stone Schoolhouse, also known as Riverside, was constructed of native stone with the stonework done by Isham Henderson. It replaced a small frame building that was built by John Shelman in 1894 on land donated by Mr. and Mrs. Sterling Hanna.

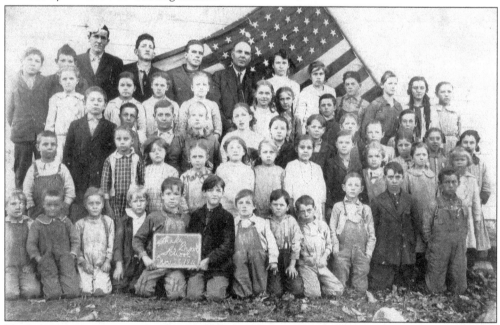

Shady Grove, a one-room schoolhouse, was six miles east of Pineville on Big Sugar Creek Road. It was constructed on what later became the site of Big Sugar Creek State Park. Students attending school at Shady Grove included children from the Alexander, Bone, Bridgewater, Bunch, Burr, Clark, Collins, Dixon, Jones, Kelly, Legore, Lewis, Meadors, Milleson, Pierce, Stevens, Studivan, Williams, and Wylie families.

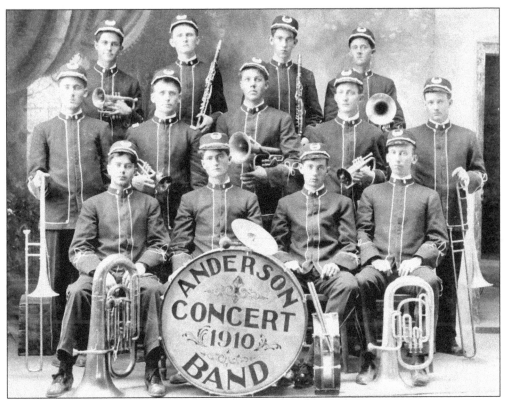

Anderson Concert Band members in 1910 are, from left to right, (first row) Jim Royce, Henry Trotter, Henry Eppard, and unidentified; (second row) Ras Clark, Lee Clark, John Allman, unidentified, and T.E. Bell; (third row) William Boyer, Judge Chapman, Monroe Elliff, and Elbert Stewart.

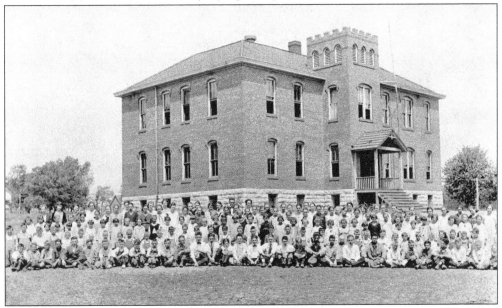

With its familiar turret, this Southwest City school building was constructed in 1910. The student body is pictured in May 1920.

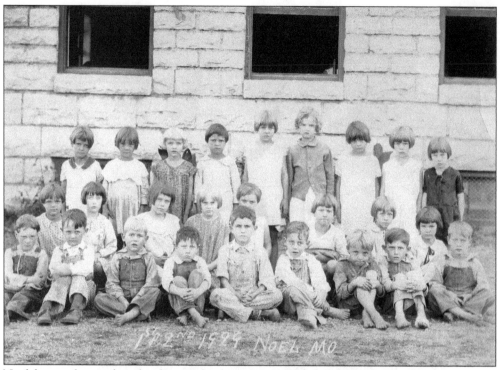

Noel first- and second-graders line up for their annual school photograph in 1929.

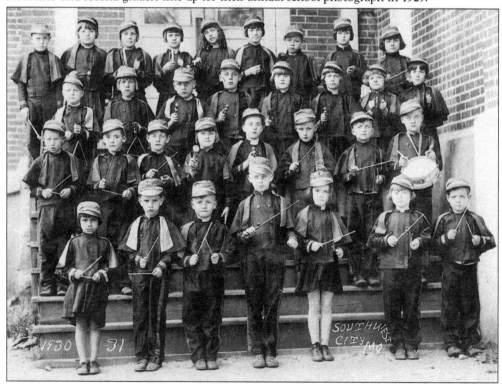

Southwest City children dress up in uniforms for their rhythm band photograph in 1930–1931.

46

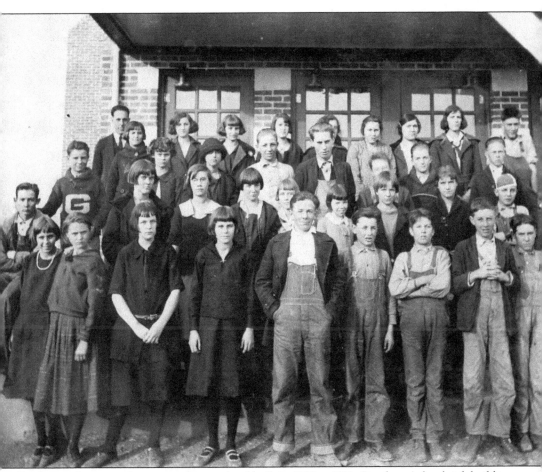

Replacing the original two-story frame school built in 1910 or 1911, Goodman's first brick building was constructed in 1922 and occupied in January 1923. The four-room frame building, as well as the first brick structure, used kerosene and gas lamps for night events. Electricity was not available until about 1925. There were no indoor restrooms until about 1930. Two outdoor privies were northeast of the school building. These Goodman seventh- and eighth-graders in 1923–1924 are, from left to right (first row) Neoma Roberts, Minnie Ellis, Ruth Adkins, Edith Roberts, Lawrence Williams, Orin Cloud, Terry Hafford, Erling Dungy, and William "Bill" Howard; (second row) Fred Smith, Lorene Brown, Sylvia Maddox, Eula Stites, Mary Jo Smith, Dorothy McGraw, Velma Loyd, Beulah Williams, and George Sprague; (third row) Monroe Neel, Syble Mitchell, Elizabeth Friend, Robert Spencer, Dorci Barnes, Robert Morgan, Cecil West, and Homer Sturdevant; (fourth row) Allie Mae Lewis, Ruby Slagle, Beatrice Lair, Frances Lee, Leura Bea Howard, Myrtle Howard, Gladys Smith, Clora Mitchell, Pete Stites, and teacher Henry Howard.

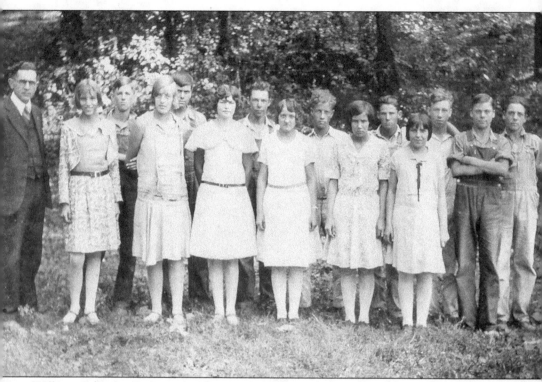

Williams School at Bethpage was known as a "Jobe High" because it had ninth and tenth grades in addition to grades one through eight. The school was housed in a two-story frame building in Elkhorn Valley a quarter-mile west of the Bethpage store. From left to right in 1930–1931 are (first row) superintendent Grover C. Pogue, Estella Maples, Thressa Forbes, Illabell Chase, Neva Murphy, Minnie Woolard, Wilma Kelley, and Howard Lee; (second row) Norma Price, William Housman, Loyd Johnson, Gerald Brock, James Woolard, Tilden Strickland, and Fred Woolard.

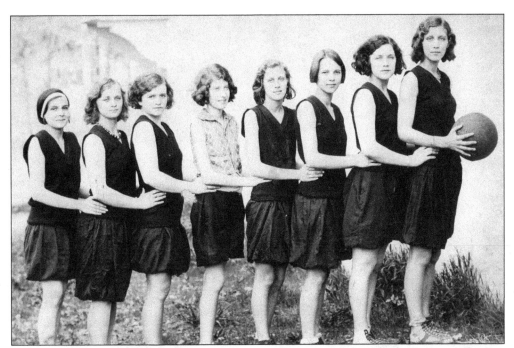

The Southwest City girls' basketball team in 1930–1931 is, from left to right, two unidentified, Virginia Queen, unidentified, Helen Thomason Queen, two unidentified, and Hazel Thomason Queen.

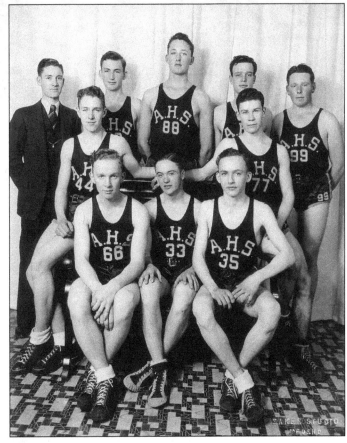

The Anderson High School basketball team in 1936–1937 is, from left to right (first row) Quentin Woods, Eldon Stratton, and William Parnell; (second row) Robert Barnes and Victor Rhine; (third row) Coach Robison, James Chapman, David Chapman, Woody Herring, and Carroll Roark. (Courtesy of Jean Stratton Bird.)

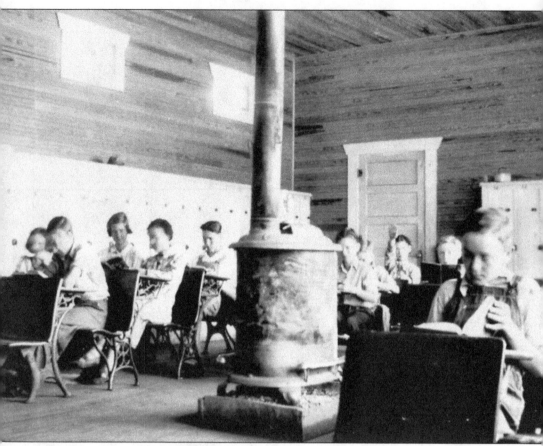

Roller School was southeast of Powell on land donated by John and Minerva "Nervie" Roller, who settled in the county in 1844. This one-room school served students in that area from the 1870s until 1956. Lucille Dalton taught there from 1951 until 1956. She remembered that the school district provided a hot lunch program in the one-room building. The cook brought water, as there was no plumbing in the building. The students ate on a long table with benches and were served family style for 15¢ per meal. In 1935, students included Vernon DeWitt (behind stove), Glen Schrader (reading book on right), Negel Hall (hand up near door), Melvin Laughlin (near stove on left), Georgia or Willa Laughlin (seated under window), and Waldon Norman (front desk under window).

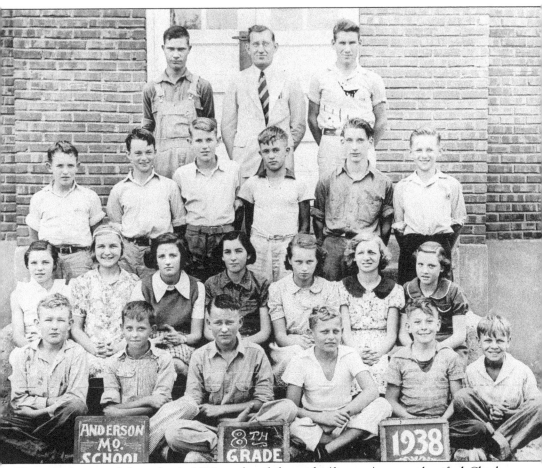

These Anderson eighth-graders in 1938 are, from left to right (first row) two unidentified, Charles Rowe, W.G. Tracy, Jackie Royce, and unidentified; (second row) two unidentified, Vella Johnson Planchon, Helen Lewis, Mary Ann Statz, Mary Freeman, and unidentified; (third row) William Roy Roark, Boonie Kelly, Calvin Mason, Joseph Pogue, unidentified, and James B. Tatum; (fourth row) Jack Robinson, Peter Nicoletti (teacher), and Bud Wallian.

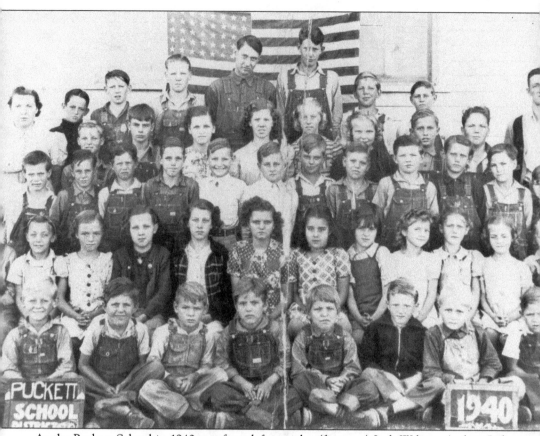

At the Puckett School in 1940 are, from left to right, (first row) Jack Wilson, Arthur Gideon, William Cook, Otis Gideon, Robert Gideon, Junior Smith. J.D. Gainer, and Malcom Mosby; (second row) Emmett Cox, Benny Joseph Martin, Delores Wilson, Phyllis Wilson, Tiny Cox, Georgia Severs, Betty Webb, June McCellen, Cloetta Cooper, Dorlene DePriest, Dolly Wilson, and Gene Haddock; (third row) ? Wallace, Robert Haddock, Clifford Gideon, Leon Sluder, Wayne Roberston, Luther Cox, Robert Wilson, Delbert Gideon, Donald Gideon, Donald Lee Guinn, Dorvan Tallner, and Peter Hunt; (fourth row) teacher Katherin Wylie, Calvin Webb, Arvin Webb, Clona Brazil, Betty McGuffy, Christene Painter, Willis Wilson, Jack Guinn, Ellis Gideon, and Cleo Wylie; (fifth row) William McGuffy, Howard Nave, Darrell Wilson, Leroy Haddock, Ray Haddock, Elmer Gideon, and J.W. Cook.

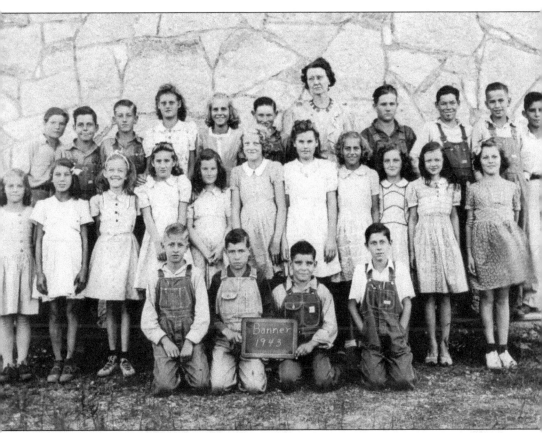

Banner, a two-room school north of Splitlog, was the last rural school to close in the mid-1960s when all schools were consolidated. At Banner in 1943 are, from left to right, (first row) Glen Eads, Paul Nicoletti, Max Brotherton, and John Campbell; (second row) Betty Jean Bergen, Betty Lou Hames, Eleanor Beth McCord, Larene McIntire, Maxine McIntire, Lena Faye Grife, Eloise Crosby, Pauline Harris, Joan Crosby, Pauline Adams, and Delores Jean Yocom; (third row) George Clark, Ernest Nicoletti, Raymond Spencer, Betty Spencer, Ruth Ellen Harris, Dale Patrick, Della Anding (teacher), Everett McIntire, Cecil Lanham, Clyde Eads, and H.A. Brotherton.

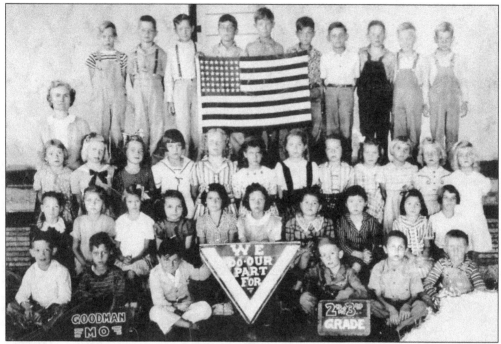

The patriotic spirit and support for the war effort are reflected in this photograph of Goodman's second- and third-graders in 1943–1944.

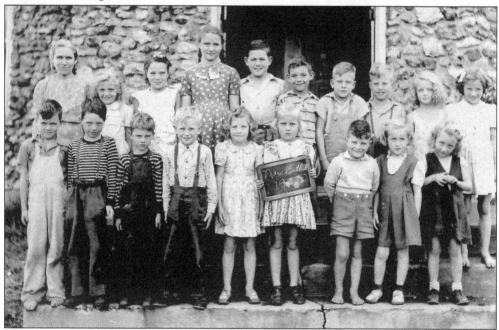

This two-room school built of native stone in 1915 served as social center, church, and school for first through eighth grades in the New Bethel community west of Anderson until 1948. It was on the property of Floyd Croddy. Some of the families attending New Bethel were the Cunninghams, Spears, Chandlers, Strattons, Pickens, Johnstons, Keelers, and Stewarts. Today, the New Bethel Schoolhouse has been beautifully restored and is open for special events.

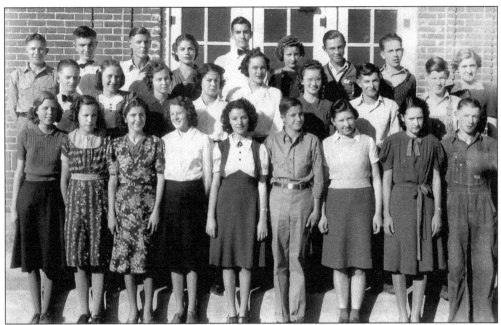

Rocky Comfort High School students stand for their class photograph in 1940.

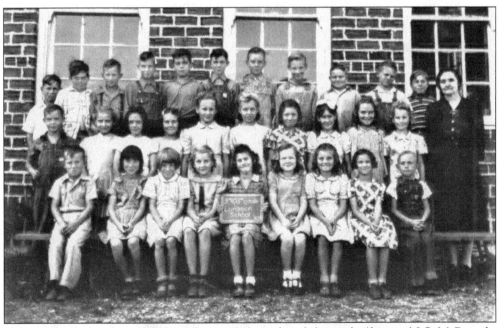

Lanagan third-, fourth-, and fifth-graders in 1943 are, from left to right (first row) J.O. McDaniels, Emma Nida, Peggy Benedict, Patsy Ruth Cantrell, Joan White, Barbara Eppard, Wilda Caywood, Phyllis Cleveland, and Benny Roy Rodgers; (second row) Danny Harner, Margaret Nimmo, Ruth Marie Bonebrake, Anna Lou Gregory, Anna May ?, Joyce Smith, Zaleta Cleveland, Della Margaret Cloud, Bonnie Shockley, Donna Burch, and Mrs. Gum; (third row) Lewis ?, George Chrisman, Charles Todd Jr., Jack Jones, Ellis Mitchell, Eugene Morriss, C.A. Harner, Gene Latty, Donald Benschoter, Jack Benedict, and Robert Caywood.

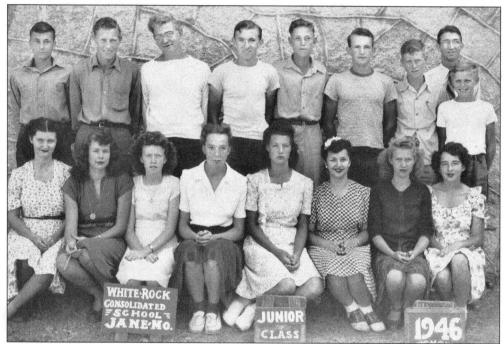

Built with Works Progress Administration funds, the White Rock School opened in 1939. Juniors in 1946 are, from left to right, (first row) Margaret Rutter, Merle Edwards, Geraldine Barclay, Patty Keene, Ruth Lewis, Doris Honey, Kathryn Nichols, and Jean Kreie; (second row) Steve Grayson, Wallace O'Brien, Donald Beaver, Arnold Cooper, Millard Henson, Robert Coffee, Charles Wellesley, and Troy Henson. An unidentified teacher stands at back right.

Bannock School, a one-room schoolhouse, was two miles east of Tiff City on Buffalo Creek. Both school and church services were held there. The community of Bannock once had a mill, general store, school, and drugstore.

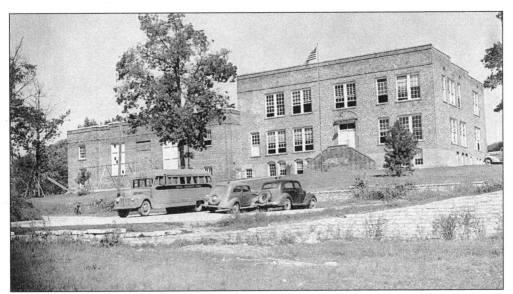

This brick building in Pineville replaced a brick schoolhouse that burned in 1921. Originally without the gymnasium on the left, it housed both the elementary and high school students.

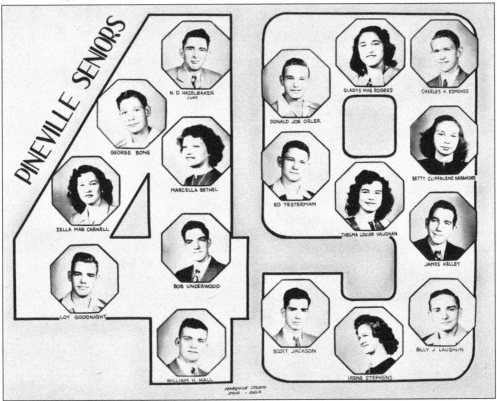

Pineville seniors in 1949 are William H. Hall, Scott Jackson, Irene Stephens, William J. Laughlin, Loy Goodnight, Robert Underwood, James Kelley, Zella Mae Carnell, Marcella Bethel, Edward Testerman, Thelma Louise Vaughn, George Bone, Betty Cliffalene Naramore, N.D. Hazelbaker, Donald Joe Orler, Gladys Mae Rogers, and Charles K. Edmonds.

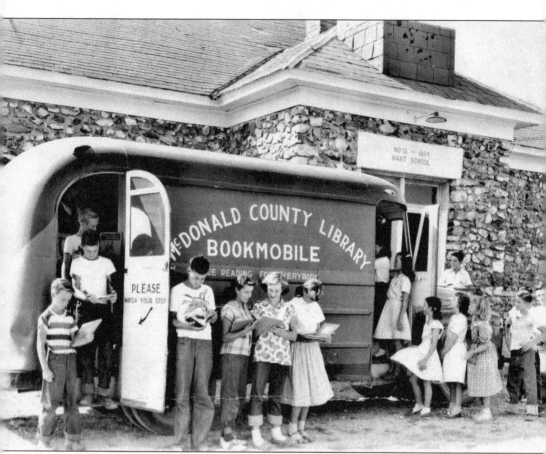

Two bookmobiles served the county from 1959 to 1976, providing an important service as the main source of book distribution to county residents. After a one mill tax was passed in 1949 to support the public library, the state provided a bookmobile for the county. With driver Ted Stoutsenberger, accompanied by librarian Zella Mae Carnell Spears, the bookmobile was on the road three weeks out of every month, visiting rural schools and stores in the small communities throughout the county. The bookmobile's arrival was almost a social event and provided an important service for students and families by bringing books to those who had limited transportation. The first bookmobile, pictured here in 1954, was created from a converted school bus. From left to right beginning with the boy in the striped shirt are Roe Lagers, Derrel Brown, Joseph Curtis, Dean Lagers, Barbara Arehart, Sarah Lynn Cook, Joann Ludiker, Doris Cummings, Charlene Ball, Beverly Brown, Viola Curtis, Corky Mills, Larry Manning, and Butch Lipe.

Five

TOWNS

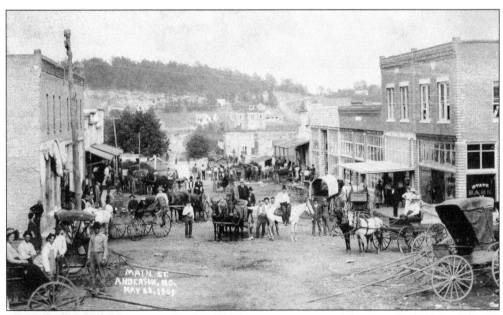

Anderson's Main Street was overflowing with buggies, wagons, and shoppers on this May morning in 1909. Families settled in this beautiful Beaver Creek valley beginning in 1840. Homes were made of logs, cows and hogs ran in the streets, and the closest train depot was a county away. But when the railroad was built right through Beaver Springs in 1891, it evolved into the busy commercial center of Anderson.

The funeral procession for John Madden precedes a simple horse-drawn hearse going up the east hill in Anderson. In 1965, several county funeral homes including Williams, Humphrey, Roller, Tatum, Nichols, and Carnell were incorporated into Ozark Funeral Homes. Purchased by Gale and Judy Duncan in 1977, that enterprise, under the ownership of B.J. Goodman, is now composed of 10 funeral homes in three counties.

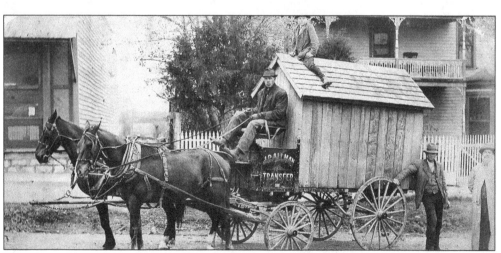

Transfer companies helped people move their sheds, houses, produce, mail, and everything in between. The Allman Transfer Company in Anderson, relying on a wagon and a team of strong horses, was one such busy enterprise.

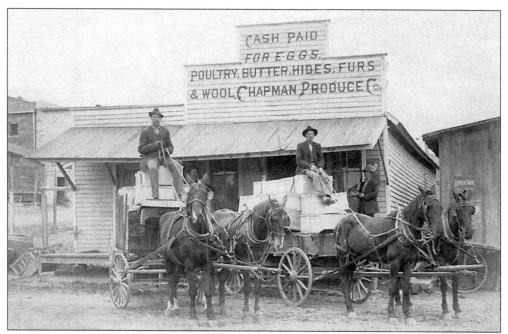

Chapman Produce Company originally featured the buying and selling of hides, feed, and eggs. Owner Harrison Jefferson "Jeff" Davis Chapman later constructed a stone building next to the railroad tracks in Anderson with his name above the entrance. That building is still in use today. A commercial success by 1909, the *Pineville Herald* reported that eggs from Chapman Produce Company were shipped out in boxcar loads.

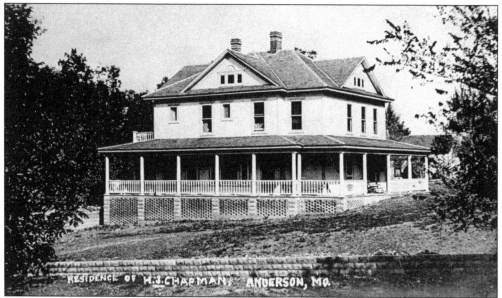

In 1908, the Chapman residence in Anderson was constructed by Jeff Chapman, son of Coleman Wood Chapman, who settled this land in the early 1850s. Note Coleman's log home in the background, in which he and his wife, Ann, raised 10 boys and one girl. When Jeff and his wife passed, the home was owned by his daughter Lois until 1980. Between 1999 and 2010, it was owned by a great-great grandson of Coleman, Al Chapman, and his wife, Pat.

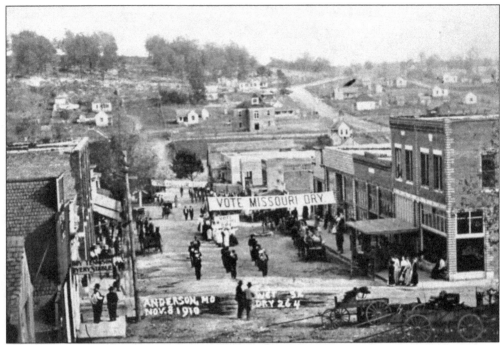

Saloons were often built on main streets of early settlements, and in the minds of many, created an unruly and unsafe environment. In 1910, the active county Women's Temperance Union held a parade on Main Street in Anderson encouraging citizens to vote Missouri dry. Results were 52 votes for wet, while 264 voted dry.

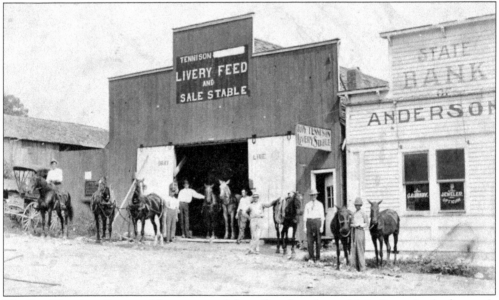

The Roy Tennison livery stable was east of the railroad tracks on Main Street in Anderson. It advertised, "If you want to drive over the county, we can furnish you elegant rigs and careful drivers." To the right are the State Bank of Anderson and the shop of G.O. Brady, jeweler and optician. Besides jewelry, Brady sold many other items such as eyeglass lenses, cufflinks, collar buttons, Elgin watches, Seth Thomas clocks, and 1847 Rogers silverware.

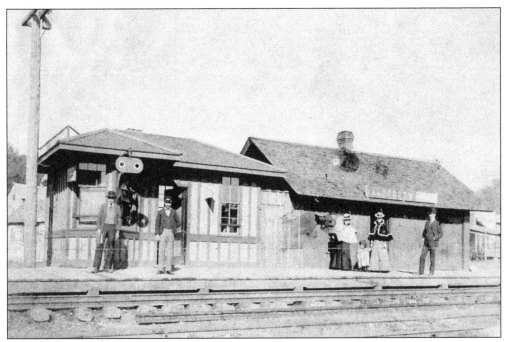

The first Anderson depot, built of wood, was replaced with a brick building one block to the south. It was a critical hub of personal travel to distant points until the middle of the 20th century. The first Kansas City Southern Railroad agent was Luther Higgs. Others included Abraham Grant Bird and James Burks. Burks was remembered as a tall man who could stand flat-footed and jump in the door of a boxcar.

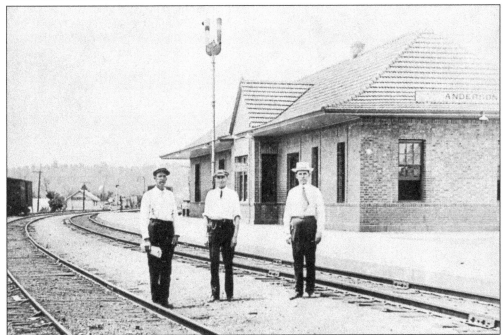

Agent J.A. Hoyder (right) stands with his assistants in front of the new brick Kansas City Southern depot in Anderson. Today it is used as Anderson City Hall.

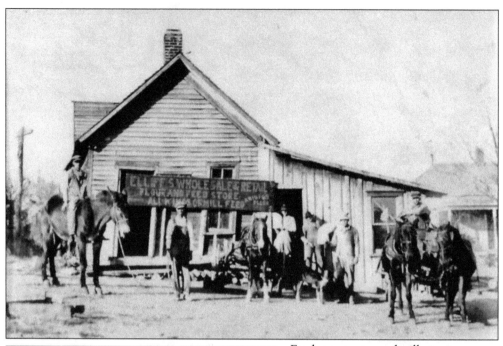

Feed stores were and still are an essential source of agricultural needs in farming communities. Some combined with general stores or gristmills, and some were part of country stores. This early one owned by the Elliffs provided farmers with a place to buy feed wholesale or retail.

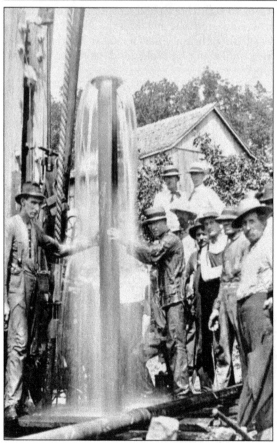

In 1909, an artesian city well dug to a depth of 1,000 feet was an important step in bringing precious water directly to Anderson residents. Up to this time, if they did not have a well, they had to rely on a tank wagon going through town with water barrels filled at Beaver Springs. Such enterprises to support the growth of the town were often promoted by the persistent efforts of Bert Dunn.

A Mr. Mason established a cooperative where he and his boys made barrels a block north of Anderson's Main Street on the west side of the railroad tracks. They were used for the apples grown in the surrounding orchards. Advertisements frequently referred to the area as the land of the "Big Red Apple." The same kind of apple was raised here that was found in Benton County, Arkansas, which was famous for its apples. A Noel apple was named best in state at the Missouri fair.

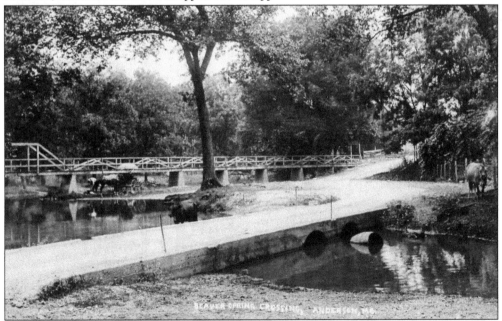

Beaver Springs, at the north edge of Anderson, was once a small village with its own post office. For many years, people gathered here for picnics and Fourth of July celebrations due to its lovely parklike setting. A walking bridge across Indian Creek was constructed by Harvey Higgs, making it easier to get to the park from town. The low-water bridge is still in use. Note the horse and buggy at left.

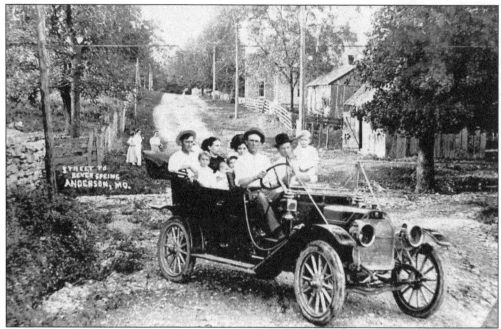

L.L. Barnes bought this new 1911 Studebaker EMT-30 from George Tatum for $1,140. It was the first car purchased in the county from a local dealer. Barnes became a successful Chevrolet dealer in Anderson for over 50 years. He advertised, "We kept in step as muddy trails turned to modern highways and gas buggies became the modern motor car."

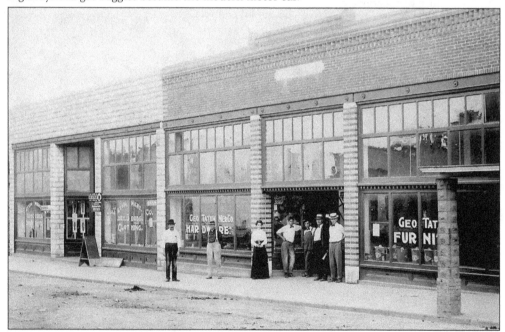

George Tatum Mercantile boasted it had "Everything you need from the cradle to the grave." Tatum started his store in Splitlog in 1889 but moved to Anderson when the railroad was completed. The store sold dry goods, clothing, hardware, cars, lumber, groceries, and farm equipment. Tatum's grandson James B. Tatum took over the family business and continued to sell farm equipment.

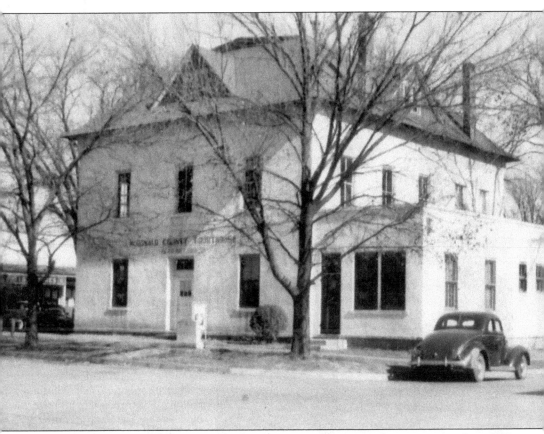

The old county courthouse on the Pineville square was the center of town activity from 1871 until 1978, when a new courthouse was erected up the street. After the building was vacated, it was saved twice from a wrecking ball: once in 1978 by local teacher Jo Pearcy, who convinced county commissioners to lease it to her for an arts center and museum, and later by the historical society, which raised money, completely restored it, and developed a museum. It is visited each year by county fourth-graders.

Lora S. LaMance—author, world traveler, and Temperance Union leader—lived with her merchant husband, Marcus N. LaMance, in the largest and most beautiful home in Pineville. Built in the 1880s, it boasted the first bathtub in McDonald County. The grounds were planted with roses and bulb gardens and rare specimens of flowers, shrubs, and trees. Lora LaMance was a powerful force in the suffragette and Temperance Union movements but was also a successful author who found time to write three horticultural books. She died at the age of 82 in 1939. In 1950, the home was sold to Pineville High School, renamed Parker Hall, equipped with modern electric ranges and refrigerators, and used by the home economics department. When county schools consolidated, the building was torn down, and the land was used as a playground for the Pineville Elementary School.

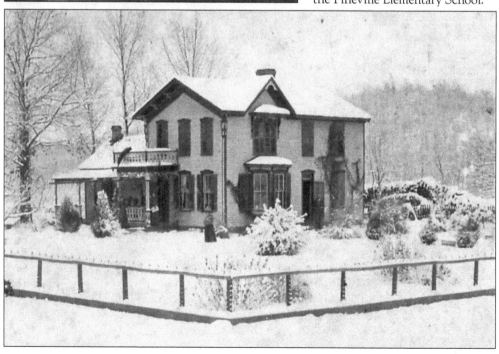

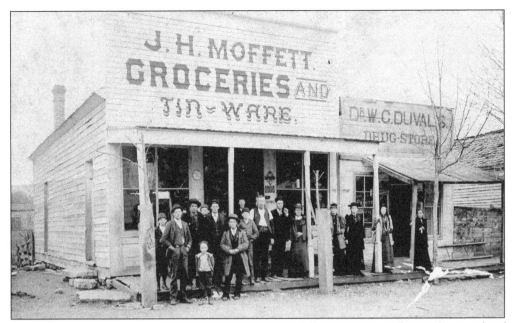

The J.H. Moffett Groceries and Tin-Ware store was built before 1900 on the northwest side of the Pineville square. Proprietor J.H. Moffett is the large man in the center of this group. Dr. W.C. Duval's Drug Store is on the right. At one time, Pineville had seven grocery stores, a hardware store, and three dry goods stores. The north side of the square is now a beautiful and well used city park.

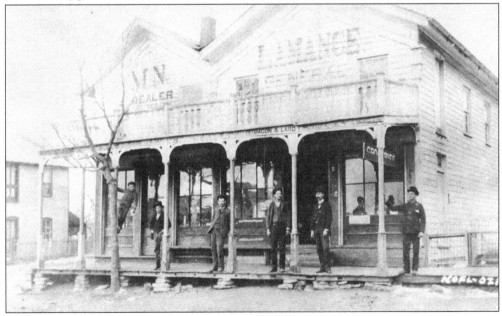

The LaMance store, on the northwest corner of the Pineville square, opened in 1866 and was a busy and successful business for many years. The six men on the porch in this 1894 photograph are, from left to right, Fred Bradley, Edward Mosier, Ab. Brown, James Walters, Claib Duval, and Julian Lamb. This wooden building was later replaced with a brick building. The store sold merchandise such as books, shoes, tin and woodenware, groceries, schoolbooks, and holiday goods for cash or produce.

Claib E. Duval was editor of the weekly *Pineville Herald* from 1883 until 1941. Every week, he intentionally set aside two copies of the paper for safekeeping. His great-grandson James Reed is now writing a series of books based on the news articles in those papers. The Chandler and Price letterpress used by Duval was made in Cleveland, Ohio. This three-quarter-ton beauty was replaced in the mid–20th century by offset-lithograph technology. The photograph of Duval with Dorothy F. Young below was taken in the *Pineville Herald* office in the old Bosserman building on the north side of the square on May 11, 1927.

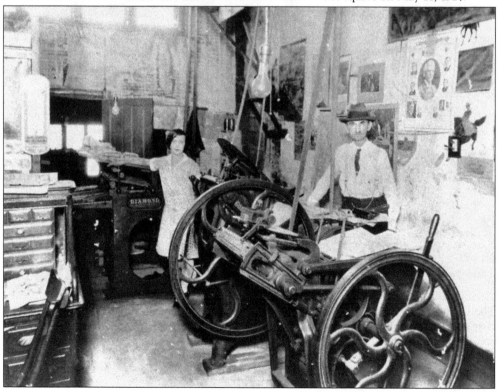

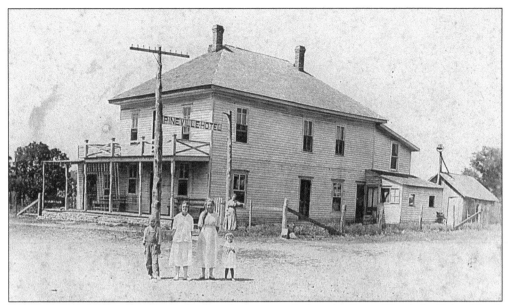

There were several hotels in Pineville over the years, including the Bacon Hotel, the Baber Hotel, the Ware, the Wilson, and the Pineville Hotel. The Pineville House was another, with P.L. Carnell as proprietor. It was advertised as the "best hotel in the county" and the "traveling men's headquarters." The Pineville House stood on the corner south of and across from the LaMance Store on the west side of the square.

The Pineville Post Office had several locations over the years. J.P. LaMance was postmaster from 1858 to 1861 and from 1868 to 1879. During the chaos of the Civil War, several helped, including Nancy Walker, Stanley Hargrove, Paul Viles, Leta Smith, Delta Chenoweth, and Hubret Lamb. In 1889, Col. James H. Moffett was postmaster. In the 1940s, it was in the center of the block on the west side of the square on Main Street. In the 1950s, it was on Fifth Street, and Minnie Manning and Joy Spurlock were postmasters.

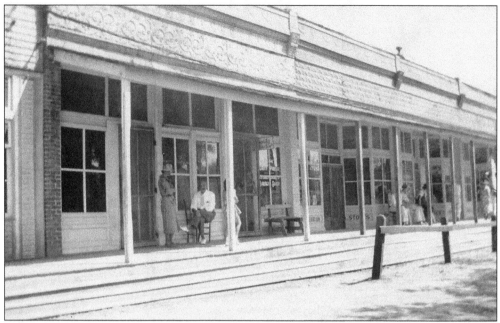

North of the courtyard square and across the street, a line of buildings served the town for many years. In 1938, Dr. William H. Horton sits outside his office. These buildings with their steps to the street continued to be occupied until torn down early in the 21st century.

Assisted by her sister Jean Brown (left), Bonnibel Sweet owned and operated Brown Sundries in Pineville from 1929 until it closed in 1978. Located on the northwest corner of the square, it offered fountain sodas and ice cream treats. It was a favorite headquarters for kids coming from and going to school. Jean and Bonnibel became surrogate parents to children, giving them friendly advice, helping with homework, and providing a sympathetic shoulder.

Lowell A. Goodman was born in Michigan in 1845. He became a nationally known horticulturist and resided in Kansas City. Always interested in the science of fruit production, he planted orchards in Howell County, Missouri, before organizing the Ozark Orchard Company of Kansas City in 1895. His orchards, located "in the heart of the Ozarks" near his namesake city of Goodman, contained 2,500 acres that he personally supervised.

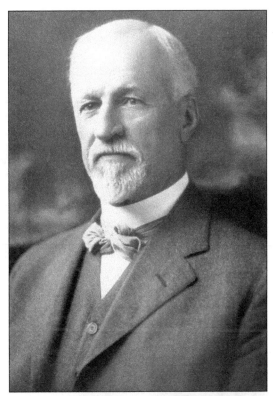

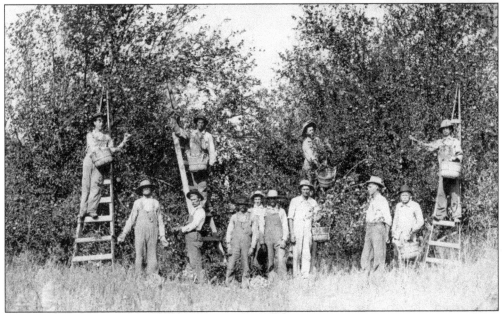

These apple pickers for the Ozark Orchard Company are, from left to right, (first row) John Browning, Harve Friend, Charley Paul, three unidentified, W.B. Whitmore, and unidentified; (second row) unidentified, John Phipps, and two unidentified. Lowell Goodman and W.B. Whitmore delivered baskets to the workers and transported workers from one part of the orchard to another using Goodman's horse-drawn hack.

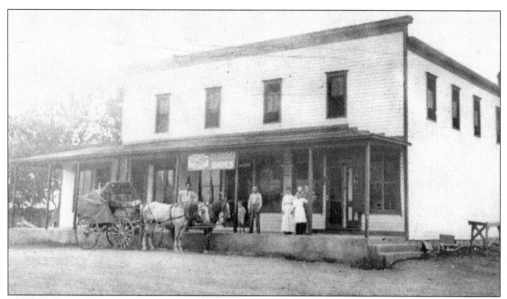

The Goodman Hotel was built on Main Street around 1904 by the Ozark Orchard Company. The company had extensive orchards and fields of blackberries in the area. Pictured from left to right are Will Stites, Murl Stites, Robert Ellis, Mrs. Robert Ellis, Ethel Ellis Phillips, and unidentified.

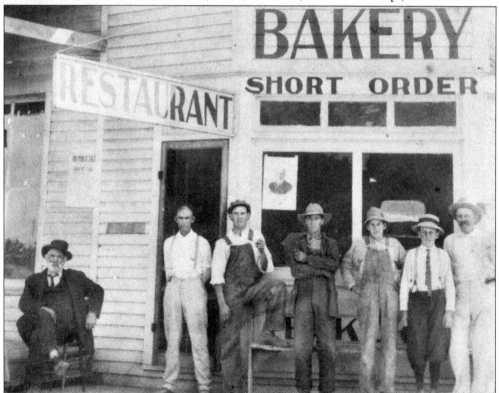

The Goodman Bakery and Restaurant was operated at different times by Albert Barrier, Robert Browning, and Josh Wimpey. Pictured from left to right are Timothy Spencer, Josh Wimpey, Ernest Stites, unidentified, Roy Phillips, Orville Stites, and James Chancellor.

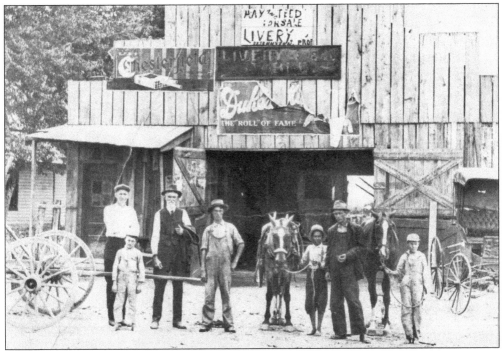

This livery stable in Goodman was on the west side of School Street where it intersects with Main Street. At the time of this photograph, B.F. Tennison was the proprietor. From left to right are Jim Friend, Oscar Stites, Henry Stites, Earl Thrasher, Mont Friend, Tom Stites, and Henry Stites.

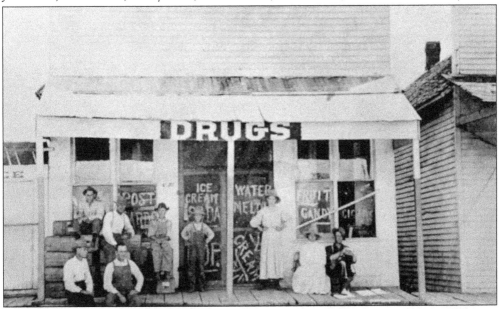

Goodman's first drugstore is pictured around 1913. It was owned and operated by Lee Campbell. The ice cream advertised was homemade, and young boys earned a dime for each batch made by hand turning the freezer crank. Adjoining this building on the left is the first icehouse in town. From left to right are (seated) Jake Pogue, Lee Campbell, ? Lane, and Peter Sturdevant; (standing) Dude Greenwell, W.B. Whitmore, Burn Lane, Emmet Lane, and ? Lane.

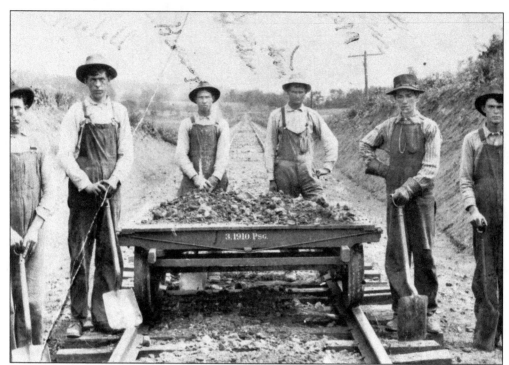

Working on the Kansas City Southern line are, from left to right, Walter Mitchell, Louis Mitchell, Robert Browning, Samuel Hutchins (foreman), William Lair, and Charles Barnes.

With the depot on Main Street, the railroad played an important role in the development of Goodman. Boxcars loaded with strawberries were shipped across the country. Passengers enjoyed traveling to Neosho, Joplin, and Noel in addition to numerous towns along the line from Kansas City to New Orleans.

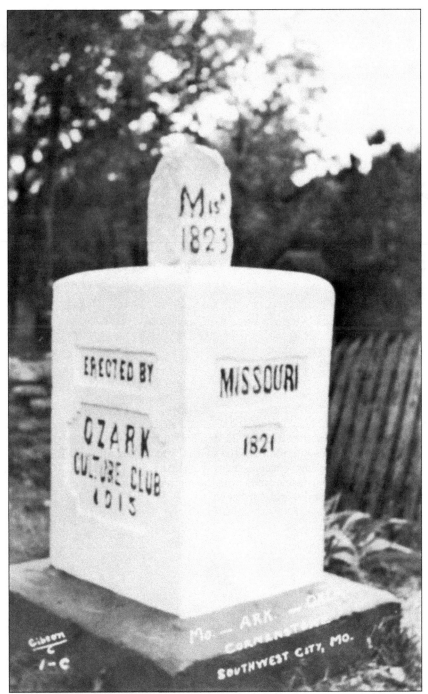

In 1823, two years after Missouri became a state, David Smith sculpted and erected a cornerstone marking the southwest corner of Missouri. At this spot, Missouri touched both Indian Territory (later to become Oklahoma) and Arkansas. When the stone was erected, it rested in an unsettled rolling prairie near a beautiful stream the Native Americans called Honey Creek. By 1850, the area had developed into a bustling frontier trading center called Honey Creek Town, now known as Southwest City. (Courtesy of McDonald County Library.)

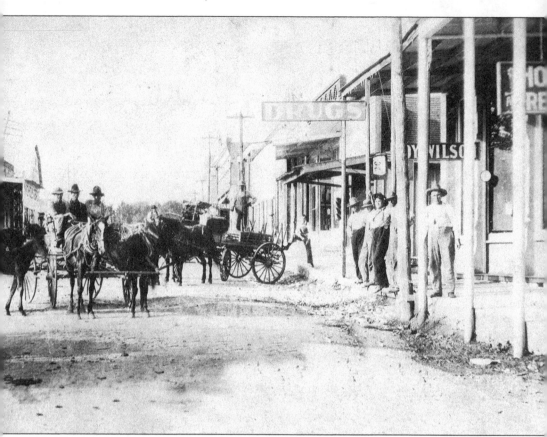

Settlers came to the southwest corner of McDonald County to farm a prairie, but it also grew into a frontier trading center with routes to the south through Arkansas and Texas and north to Kansas City. In 1838, Cherokees arrived at the end of their Trail of Tears, and a flourishing trade developed with white settlers. Businessmen from the south came and built stores, boardinghouses, hotels, saloons, gristmills, banks, and distilleries.

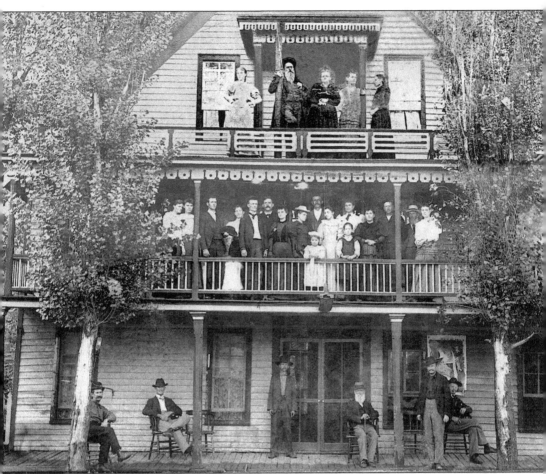

The Corum House hotel was built by Confederate colonel J.D. Shields in 1870, the same year Southwest City was platted. He is the man with a beard seated on the lower porch during this 1892 wedding reception for Jeptha Howe and Irene Jones, who are on the top porch with George and "Aunt Mag" Corum. The hotel was on the east side of Main Street facing west. Aunt Mag Corum advertised "well-ventilated, elegantly furnished rooms, a good meal, a comfortable bed and a good stable." She asked no questions of her boarders, who included settlers going west, businessmen, and outlaws such as the Doolin Gang, the Starrs, the James brothers, and the Daltons. The Corum House burned in 1903. It was reported that the old bell in the tower tolled its own demise as the walls caved in. (Courtesy of McDonald County Library.)

R.W. Covey, his wife, and his sons were owners of Southwest Milling Company. J.P. Covey opened a hardware store in 1884, and the family became merchants dealing in dry goods, clothing, shoes, hats, furnishings, staple and fancy groceries, county produce, tinware, and glassware. The Covey family members were prominent business and civic leaders in Southwest City for many years.

This three-story mill was moved in pieces to Southwest City from Gravette, Arkansas. It had a full roller process with the ability to produce 50 barrels of flour a day. Originally built to be run by waterpower from Honey Creek, it was later converted to steam power with a boiler and tall smokestack. Owners and operators over the years included J.L. Woodward, Glen and Henry Spillers, D.L. Morris, and D.L. and J. Ross Nichols.

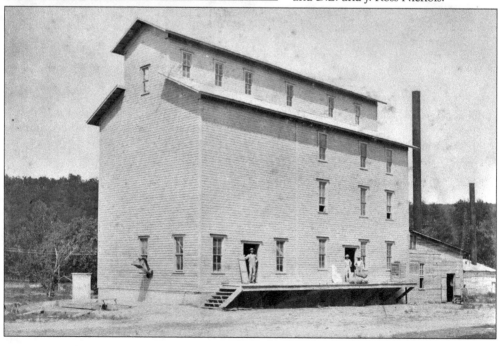

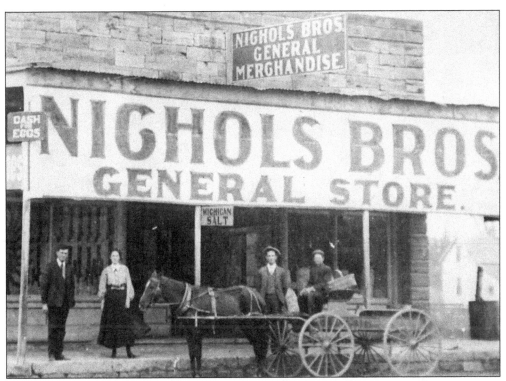

In 1904, Martin and John Nichols established a grocery and shoe sales business on Main Street in Southwest City. In 1924, they constructed a concrete addition to a building once occupied by the D.E. Haven Store. A full basement was originally used as a funeral home. By 1949, the store extended the full block to include hardware, furniture, appliances, farm equipment, groceries, dry goods, clothing, and a bargain basement. (Courtesy of McDonald County Library.)

Dr. Edward Croxdale lived and practiced medicine in his Southwest City home for 42 years. He graduated from the University of Tennessee Medical School in 1900 and moved to Southwest City in 1911. Early in his practice, it took days to get to the nearest hospital, and he and his patients seldom went. Transportation was slow and roads often impassable. His beautiful home was later restored and became the Lawson Funeral Home. (Courtesy of McDonald County Library.)

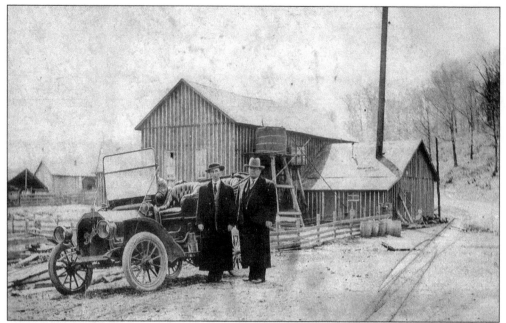

Men stand in front of a successful distillery around 1912. The Women's Christian Temperance Union, strong in McDonald County, successfully campaigned to drive saloons out of business due to frequent brawls and gunfights. Saloons were being closed in McDonald County around 1914, and by 1917, it was illegal to manufacture whiskey. But stills, commonly found in the hills since 1830, remained.

A group of dashing young men and women pose in Southwest City about 1910. They include, from left to right, (first row) Lelah Brown, May Stevenson, Ollie Sayer, Flo Brown, and Alice Thornton; (second row) Mr. Holler, Bess Nichols, Erma Dunlap, Earl Nichols, Mable Covey Nichols, John Boyd, and Fannie Smith Boyd.

Six

CULTURE OF CARING

The people of McDonald County inherited values of hard work and honesty within a culture of caring about family, God, and country. In 1926, the Bert and Dollie DeWitt family, with Bud Larkin Washington standing in back, sit outside their home in Mountain Township. They may have been poor in possessions but not in things that mattered. They had plenty of food to eat, clean air and water, and beautiful surroundings, and they worked hard with folks who cared about them.

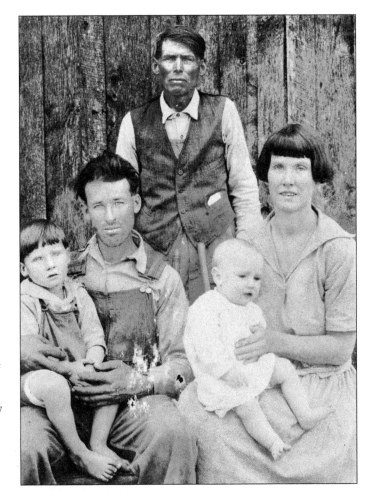

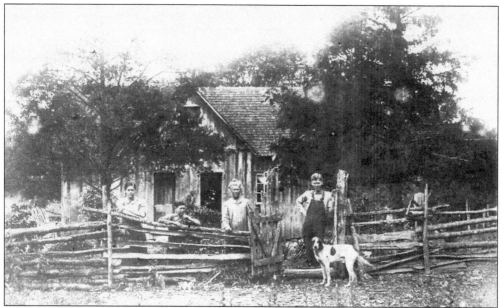

Homesteading was a challenging lifestyle. They worked hard, enjoyed simple pleasures, and were ready to help neighbors in need. A.G. Buttram of Anderson wrote in his book *80 Years in the Ozarks*, "When a neighbor needed assistance, all neighbors would go to their rescue. If it were to help roof a house, help cut the winter's wood, plough a day if they were behind, or should one be so unfortunate as to lose their home by fire, the neighbors were always ready to render aid without compensation."

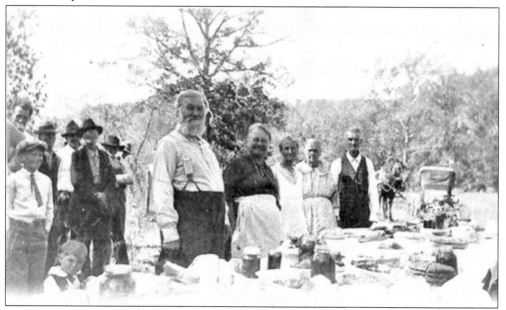

Families in Mountain Township looked forward to the Fourth of July picnic hosted by Henry Jr. and Polly Schell. They enjoyed visiting and eating delicious baked goods as well as fresh vegetables from summer gardens. Children enjoyed a variety of games and activities. Celebrating with and supporting neighbors in the good times was important because they knew they could be depended on during the difficult times.

Minerva Schell Comstock Fry is seated in front of the Jacket Store around 1915. Her first husband, Warren Comstock, was killed during the Civil War by bushwhackers who frequently ravaged McDonald County.

The DeWitt family lived on Tommy Cooper's land in Bentonville Hollow in Mountain Township. In 1908, this humble family included, from left to right, "Bert" Andy Virgil, "Sally" Sarah holding Larkin, Lilly Mae, George, "Bud" Larkin Washington, Elsia, and Frank Leon.

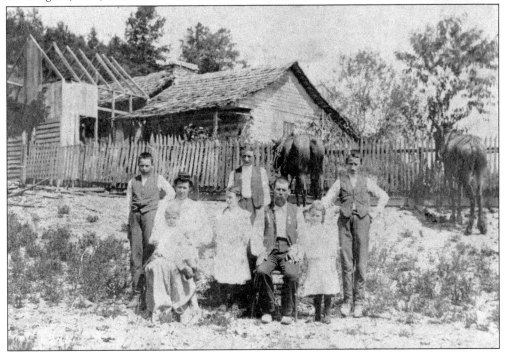

God was central to the lives of McDonald County people. The Bible was an important book in every home, and Sunday church attendance was a must. Jesse and Nancy Schell are seated here with their precious and quite large family Bible in 1927. Pages included complete names and dates for births, marriages, and deaths for family members.

After listening to the sermon and singing praises to God, people looked forward to church socials. Antioch Church of Christ members pictured here enjoy food and fellowship in 1928. Members of the church, established on July 18, 1882, included the Schell, Clanton, Evan, Hall, Vaughn, Carden, Armstrong, and Roller families.

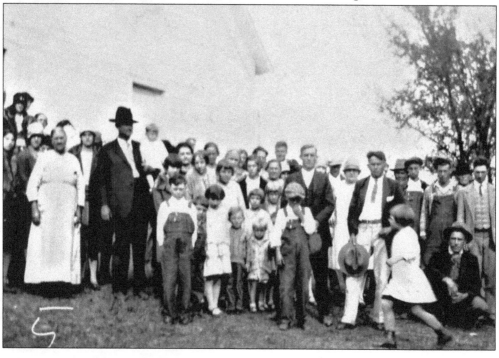

Around 1857, the Coleman and Ann Chapman family left Tennessee for Missouri. When traveling through Beaver Springs, they met James Washington Tatum. Upon finding out Coleman was a minister, Tatum talked him into buying land there and serving as pastor of the Baptist church. Coleman worked as a wagon maker and farmer in addition to being pastor of the Anderson church, which at the time was constructed from logs.

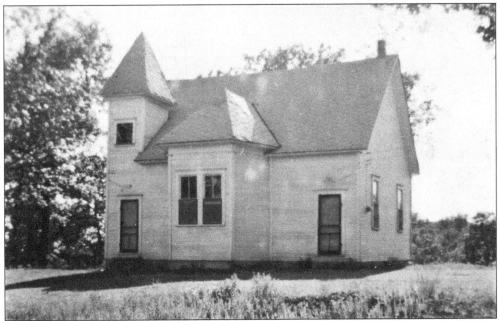

The Simsbury Church was first organized at the Enterprise Schoolhouse in 1905. In 1914, friends and neighbors, with a great desire for a church building in the community, began digging a foundation and pouring cement. Men skilled in carpentry came together to construct the frame, and painting was shared by all. Children worked in a variety of chores, such as carrying stones for the foundation. (Courtesy of Chris Beck.)

David A. Akehurst, United Brethren minister, spent every summer holding protracted meetings or revivals. They were outdoor events held in brush arbors. Reverend Akehurst also preached regularly in a variety of schoolhouses where people looked forward to hearing him. He passed away at his home in Little Missouri Hollow on October 31, 1933. (Courtesy of Shira Akehurst.)

Union Church on Highway 76 was established in the 1880s. The church has been used by several denominations and had periodic revival meetings, which were well attended and could go long into the night. It is still holding services today.

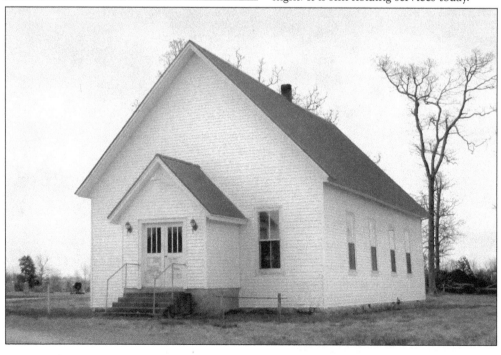

The First Baptist Church of Anderson is one of the oldest churches in Southwest Missouri, founded on July 1, 1848. Henry Miller conducted services in his home until a white framed church building, shown above, was erected at the edge of town near the Beaver Springs Cemetery. After the Civil War, Rev. Coleman Wood Chapman became minister. In 1911, construction started on a redbrick building with a bell tower and stained-glass windows. It was completed in 1912, and by 1914, the church directory included 439 names.

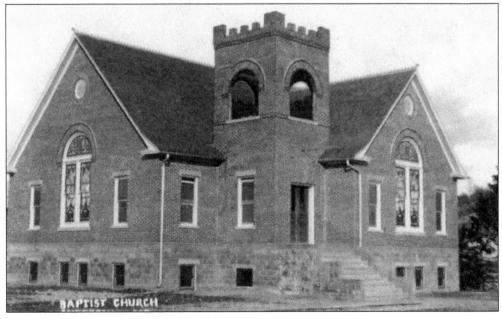

The Success Schoolhouse was built in 1888 half a mile south of Bowers' Corner. It was known to have an all-day Sunday service with a basket lunch. Such services, with sermons, singing, and food, were common, well attended, and enjoyed by everyone. This schoolhouse is now the home of Loveland Primitive Baptist Church.

Rev. Henry Stites and his wife, Jane, started preaching at Goodman Baptist Church in April 1908. The reverend also held the position of postmaster in Goodman. When he died on his way home after giving a sermon, his horse took the buggy to his front door.

The love of country is evident in the sacrifices of men and women of McDonald County. They were quick to serve in the armed forces. Many came from the same family home, and some paid the ultimate price with their lives. The Braden and Harriet Spears Clark family moved to McDonald County in 1901 from Arkansas and eventually settled northwest of Anderson, where they raised strawberries and tobacco. Six of their nine sons, Howard, Orville, Joe, Arthur, Allen, and Virgil, were members of the 203rd "Houn' Dawgs" National Guard regiment. Their picture was printed in *Stars and Stripes*, the armed forces newspaper, and used for recruiting.

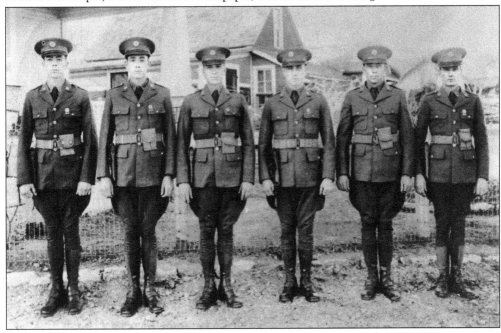

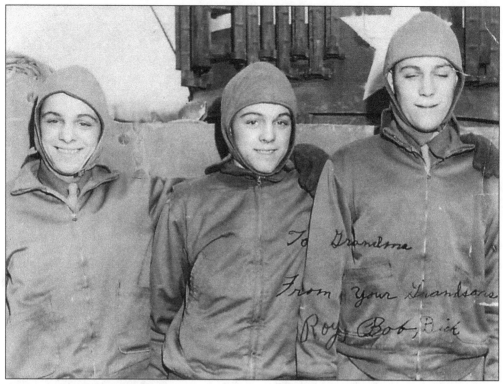

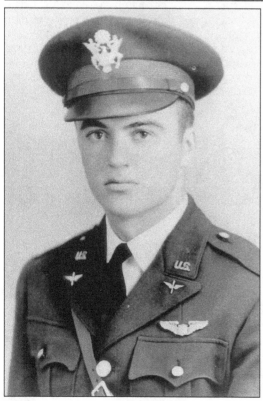

From left to right, Richard, Robert, and Roy Houseman were the first triplets to be inducted into the Army and assigned to the same unit. Their mother had requested that they serve together. The triplets were in "Darby's Rangers," an elite corps, and served from 1942 to 1944 in North Africa, Italy, and France. Roy was wounded in Italy, Robert was captured and imprisoned in Germany, and Richard continued to serve in France throughout the war.

Eldon E. Stratton was a 22-year-old McDonald County World War II pilot who was shot down and killed in action over the Pacific on August 30, 1943. He received the Silver Star, Distinguished Flying Cross, Air Medal, and Purple Heart. His nickname was "Scrap Iron," because he was always able to fix things when no supplies were available. Stratton was chosen as one of 18 to fly in Operation Vengeance, which successfully shot down Japanese admiral Isoroku Yamamoto, who had planned the attack on Pearl Harbor. (Courtesy of Jean Stratton Bird.)

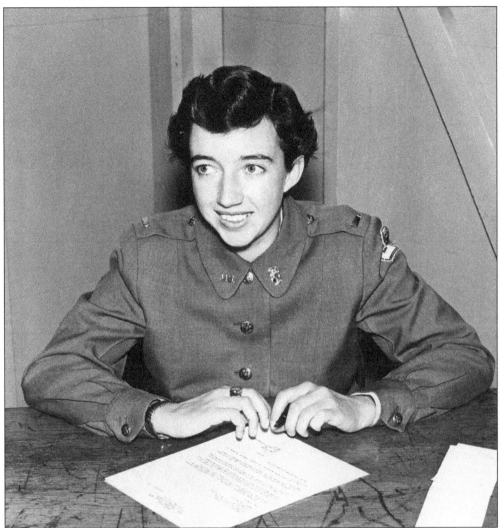

Ruby Rose Stauber was born in 1928 on the Stauber farm in Noel. She joined the Army in 1951 and served 31 years in the Women's Army Corps commanding a platoon, company, and battalion. She was one of the first female officers and served in a variety of roles, including public affairs officer for V Corp, editor-in-chief of *Military Review*, deputy public affairs officer for the US European Command, and commander/editor-in-chief of *Stars and Stripes*. Her colleague and friend, West Point graduate and Korean War veteran James Tatum, said, "If she had enlisted some years later, she would have become a general." Rose was one of the early leaders in the McDonald County Historical Society and wrote several books on county cemeteries. Her large collection of worldwide US military photographs can be found in the Missouri Historical Society archives.

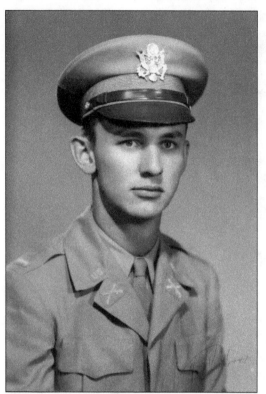

In 1947, James Bernard Tatum was the first McDonald County resident to graduate from the US Military Academy at West Point. After being wounded in the Korean War, he returned home to run his family's business in Anderson. Passionate about the importance of community colleges, he co-authored legislation creating community colleges in Missouri and led the campaign to create Crowder College. Tatum was elected the first chairman of the board of trustees of Crowder College, a position he held for 45 of his 50 years at Crowder.

A.C. Price attended Massachusetts Institute of Technology Air Service School and Cornell University Photographic School. After being commissioned into military service in 1917, Price installed and tested instrument panels for experimental aircraft at McCook Field in Dayton, Ohio. He documented this critical time in history by photographing test planes and pilots including Orville Wright and Eddie Rickenbacker. Price retired to his farm in McDonald County and was later an extra in the 1938 *Jesse James* film.

Seven

LAND OF A
MILLION SMILES

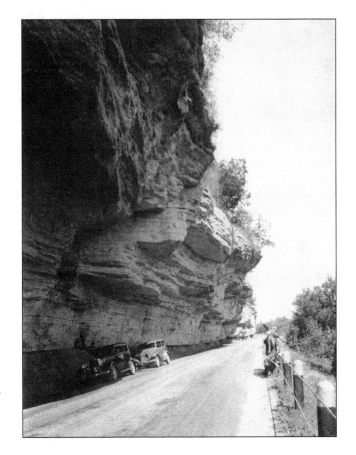

About 1892, a road called Ozark Trail was built under the now-famous overhanging bluffs. In the mid-1920s, the road under the bluffs was surfaced with gravel and became known as Highway 1. Most overhanging bluffs were cut and blasted away when developing highways, but Caroline Avery was instrumental in preserving the overhanging bluffs that became known as Avery Bluff. The limestone bluffs remain one of the most picturesque spots in the Ozark region.

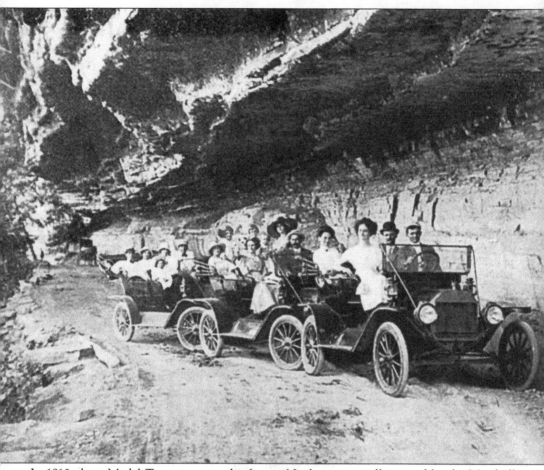

In 1910, these Model T cars, among the first in Noel, were proudly owned by the Marshalls, Harmons, Caldwells, and St. Clairs, Noel's early business entrepreneurs. They came across the river to this place on a pontoon bridge. A scenic drive between Ginger Blue and Noel became known as the "Prize Drive of the Ozarks." Driving this road as it winds along Elk River and under the overhanging bluffs has always provided a thrilling and delightful experience for tourists and residents alike.

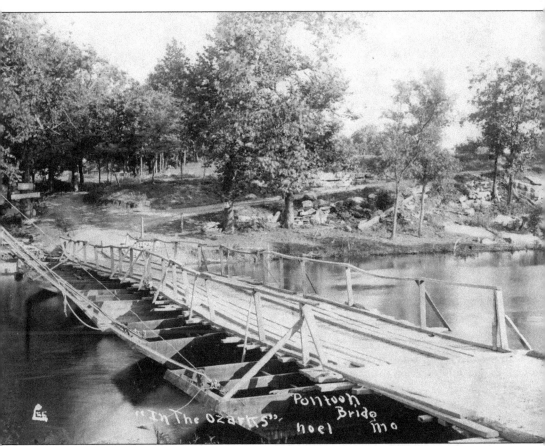

"In The Ozarks" Pontoon Bridge noel mo

Just north of Noel was the Elk River Ford, where a pontoon bridge was installed in the early 1900s. The bridge floated on supports and was tied at each end with cables. At the start of the high-water season, one end of the cable would be undone, letting the bridge float with one end downstream while the other end was securely tied to a firm support. After the river went down, the floating end would be pulled back and secured at its anchor. Daniel Frye was the caretaker of the pontoon bridge for many years. A horse and buggy could cross for free, but the cost was 25¢ for a motor vehicle.

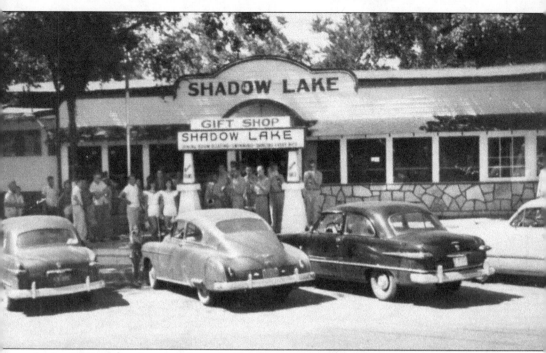

In the 1890s, railroad workers from the Kansas City, Pittsburg, and Gulf Railroad built the O'Joe Fishing Club House on this piece of property to relax and enjoy the natural beauty and serenity of the area. Marx Cheney purchased the clubhouse in 1925 (changing the name to Shadow Lake) and brought in bands to provide live music and dancing. Popular bands played nightly and for the tea dance on Sunday afternoon. Shadow Lake gained national attention in 1938, when the movie *Jesse James* was filmed in the county. Stars Henry Fonda, Tyrone Power, Nancy Kelly, and Randolph Scott enjoyed dining and dancing there, much to the delight of thousands of locals and tourists. With the establishment of Camp Crowder in Neosho during World War II, Shadow Lake became so popular with the soldiers stationed there that it was declared off limits for the trainees.

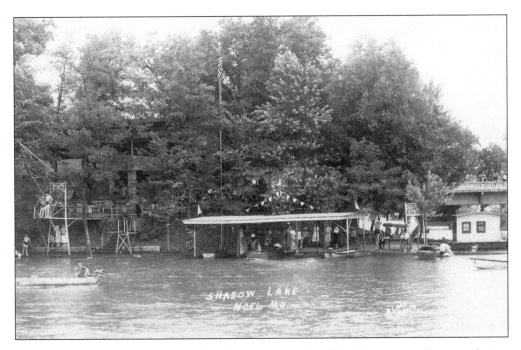

Shadow Lake and the Elk River have played a prominent role in Noel's history as well as contributing to the local economy. In addition to dancing the night away in Shadow Lake's pavilion, area residents and tourists were lured to the cool, clear water of the Elk River, which provided opportunities for fishing, swimming, boating, and floating. Couples and families enjoyed renting and then trying to maneuver paddle boats in the river. At one time, the resort operated Chris-Craft inboard speed boats, which often made over 80 trips a day for 50¢ per person. Shadow Lake has provided rich memories for many over the years.

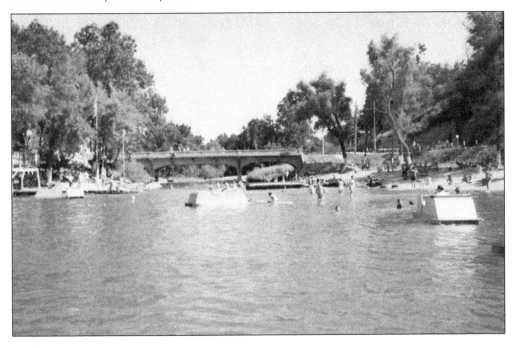

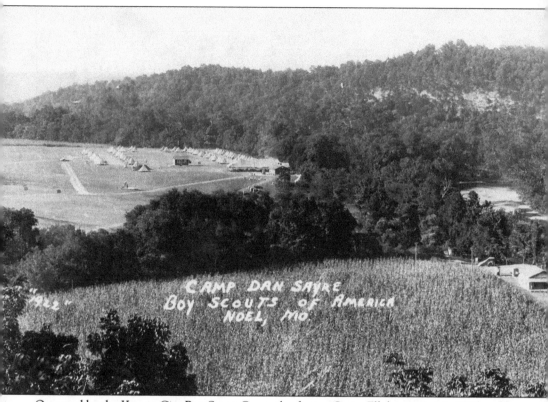

Operated by the Kansas City Boy Scout Council—first as Camp Elk beginning in 1916 and later as Camp Dan Sayre—hundreds of Scouts experienced adventures of a lifetime at this camp every August for two weeks. Each summer, more than 500 young Scouts from both Kansas and Missouri rode the train to the camp at Elk Springs. The train ride was a rare treat. Once they arrived at the camp, they headed right to the river to enjoy the fresh, cool water, the diving platform, and the giant water slide. The camp boasted a shoot-the-chute, a giant slide that catapulted Scouts into the river at high speeds. In addition to swimming in the river, Scouts had the opportunity to hike, explore caves, and enjoy campfire programs.

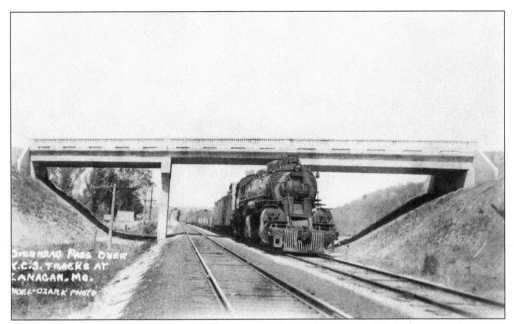

The railroad was instrumental in developing tourism in the county. With depots in Lanagan, Anderson, and Noel, the Kansas City Southern Railway brought thousands of passengers to the area to enjoy the beauty of the region and the hospitality of the numerous resorts. The *Flying Crow* was later replaced by a diesel-powered locomotive called the *Southern Belle*.

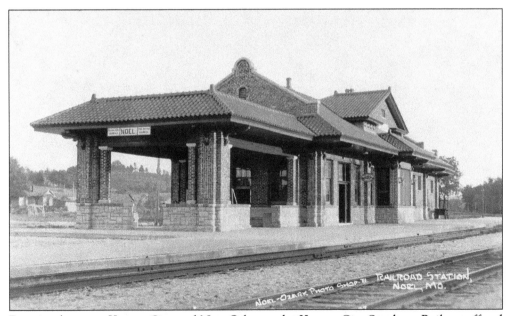

Running between Kansas City and New Orleans, the Kansas City Southern Railway offered passenger train service through the 1960s. The last passenger train passed through Noel in November 1969. The depot now serves as Noel City Hall.

Welcoming hundreds of visitors to the community, the City Hotel in Noel was built by a Mr. Leek in 1893. Located on Main Street in the center of town, it was later purchased by Clarence Davis and enlarged in 1898. (Courtesy of Tammy Clark.)

On the banks of the Elk River in Noel, 38 Carthage marble steps and four limestone terraces were built in 1900 by C.E. Davis. A pavilion was added shortly after and was used for band concerts and local gatherings.

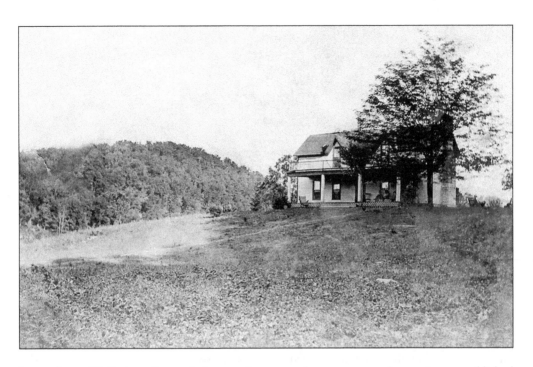

Located near Elk Springs, Riverside Inn may have once been a stagecoach stop. It was established as a tourist resort about 1905 by W.H. Fleming. Overlooking the Elk River, the resort contained a main lodge, dining hall, livery stable, and cottages. It was advertised as "an ideal place for those who wish to enjoy a real outing close to nature—just the place to spend the summer with your wife and children." Scattered among the trees were cottages with screened porches furnished for sleeping only. A brochure from 1913 advertised "first class home cooking and fresh meat, chicken, and fish at all times. Good butter with plenty of fresh vegetables and iced tea make our meals a drawing card. Water is supplied from an artesian well and is as good as can be found anywhere in the world."

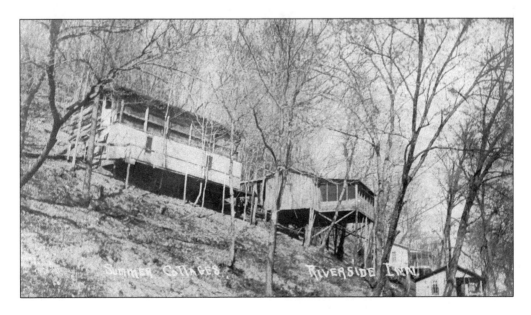

Established in 1915 by a Kansas City Southern Railroad executive, Ginger Blue Resort was built on a limestone bluff above the Elk River along the picturesque Prize Drive. This summer lodge was built for city residents who wanted to get away to enjoy the area's natural beauty and relax by swimming and fishing in the Elk River. The resort flourished as it drew thousands of visitors to the area. Meals were served in the main lodge dining room overlooking the river. Guest rooms were in the main lodge in addition to accommodations in riverside units and cottages. Guests could enjoy canoeing, float trips, tennis, horseback riding, and swimming in the pool as well as the river. It was remodeled over time, but continued to offer fine dining for tourists and locals throughout the 1900s.

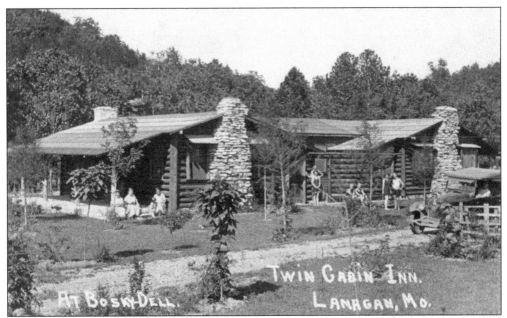

A tourist attraction along the east side of Indian Creek near Lanagan, Bosky Dell had a lodge and several log cabins providing a good spot for swimming, fishing, floating, and family outings.

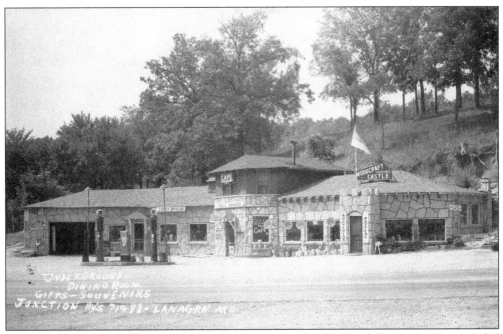

In Lanagan across from Truitt's Cave, a unique industry called Shellcraft Shelter Studios provided employment for many. Located in the back of the Wishing Well Café, it was a factory for woodcrafts that were shipped all over the country. The café was a bus stop for the Crown Coach Lines and featured a showroom with souvenirs and an opportunity for customers to choose their trout from a tank of fresh spring water coming from an underground stream.

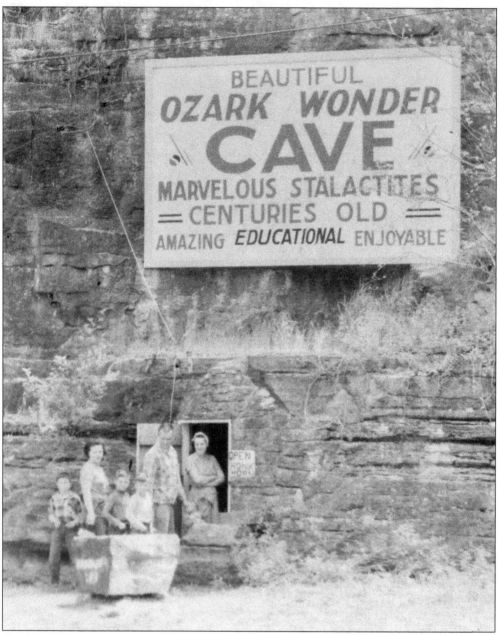

Ozark Wonder Cave was the first cave opened to the public in McDonald County. John "Dad" Truitt, born in Illinois in 1864, found the entrance to the cave in 1916. He had participated in the Oklahoma land rush, homesteaded in Oregon, adventured in Mexico, and worked at the Cave of the Winds in Colorado. After hearing from visitors that there were many "holes" in the Ozarks, Truitt and his wife arrived in Elk Springs in 1914 to claim and develop a cave he had heard about. He worked for months to find the entrance. In 1916, his cave was inspected and approved for commercial use by the State of Missouri. For a brief time, Truitt leased Bluff Dwellers Cave from the Browning family before buying Indian River Highlands near Lanagan and opening his last cave, Truitt's Cave. He helped discover, explore, develop, and promote many caves in the area and became known as "Cave Man of the Ozarks."

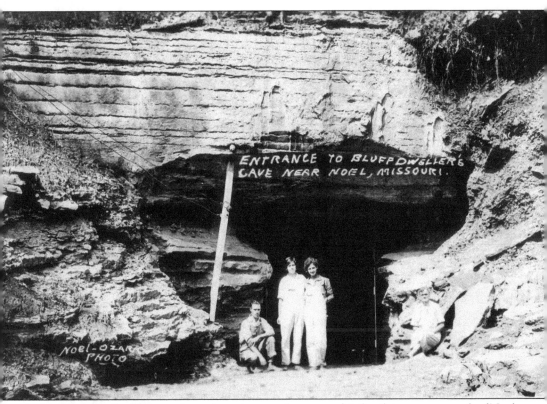

Arthur Browning had known about the existence of a cave on his family's property south of Noel since 1901. While checking traps on his property in 1925, he noticed a cool breeze blowing from a limestone outcrop. Two young surveyors with the highway department, Robert Ford and Bryan Gilmore, offered to help Browning gain better access to the cave by moving loose rock and debris so it could be explored. They found two natural openings that had been hidden by a landslide. Artifacts in the landslide debris indicated Native Americans had used the cave for occasional shelter and storage. Although Browning was not interested in opening the cave for tours, he felt pressure to do so from Noel city leaders because of the economic benefits the cave could bring. In 1927, he relented and opened Bluff Dwellers Cave to the public for tours. It is still owned by the Browning family.

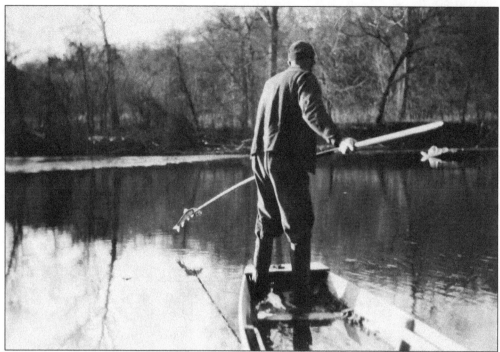

Gigging, a popular activity in the clear streams throughout the county, provided fun as well as food for a family. Some young men were exceptionally good at it, and a fish fry would follow their productive day on the water. Gigging in 1928 in the calm, clear water of Big Sugar Creek, this fisherman demonstrates his skill honed through practice and patience. (Courtesy of Lyons Memorial Library, College of the Ozarks.)

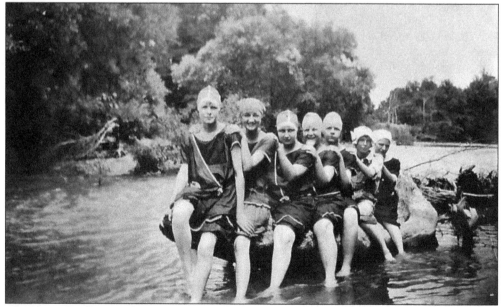

These teenage friends from the Belmont community celebrated the Fourth of July in 1923 at Indian Creek. From left to right are Cora Dobbs, Lena Groom, Georgia Eppard, Jean Eppard, Nell Dobbs, Anna Stalker, and Ida Stalker. (Courtesy of Tomas Lockhard.)

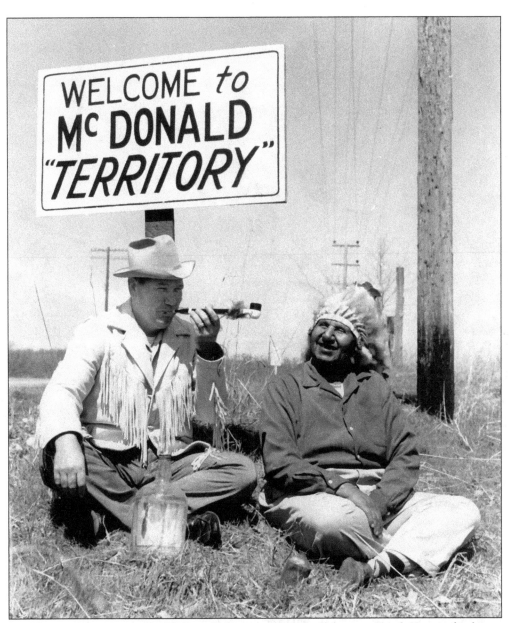

In 1961, many tourist towns in McDonald County were left off the state *Family Vacationland* map, and the "craziest 'secession' protest you have never heard of" was launched, according to Dwight Pogue's book *1961 Ozark Breakaway: The Year McDonald County Seceded from Missouri*. Here, self-proclaimed chief Henry Saugee from Oklahoma smokes a peace pipe with newly elected territory president Zeke McCowan. Saugee told reporters he would support making the new McDonald Territory an independent nation. The mayor of Noel, Daniel Harmon, met with Ralph Pogue, the editor-owner of the *McDonald County Press*. Pogue was an avid fan of Mark Twain and knew for a secession to succeed it would have to be a good-natured one without anger or revenge. These two fifth-generation McDonald County men worked with state senator Lee Aaron Bachler, who presented a legal document for secession on the floor of the state capitol building. (Courtesy of Ralph Pogue.)

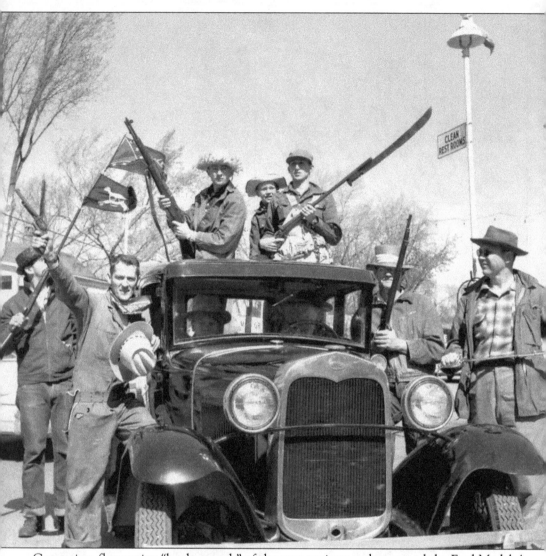

Gun-toting, flag-waving "border guards" of the new territory gather around the Ford Model A used as an official secession vehicle. According to *1961 Ozark Breakaway*, on Thursday, April 6, 1961, Pogue contacted the *Joplin Globe* and gave it an exclusive scoop of the plans. The *Globe* ran the story on the front page of its Saturday edition, April 8, and it was picked up by the Associated Press and the United Press International to appear in daily newspapers across America. It made the front page of the *Chicago Daily Tribune* on April 12, and was filmed for television news coverage in Joplin and Kansas City. McDonald Territory stole the hearts and minds of Americans during the summer of 1961, and its plight was featured in the *Los Angeles Times* by celebrated news commentator Raymond Moley. The story ultimately made the *New York Times*. (Courtesy of Ralph Pogue.)

"We Stand Ready To Defend Ourselves Against All Aggressors"

McDONALD TERRITORY
VISA

I, the undersigned, President of the McDONALD TERRITORY, hereby request all whom it may concern to permit safely and freely to visit in, or pass through

Sgt. James "Jim" Stevens of the border patrol had collected and happily provided many old guns to the men, including his Kentucky muzzle-loading rifle. According to his wife, Pat, who wrote a book on the secession, Jim told tall tales in a convincing manner to the many tourists who flocked to the area. He was already a local hero from World War II. When he died in 1970, school was dismissed so the local children could attend his funeral. (Right, courtesy of Ralph Pogue.)

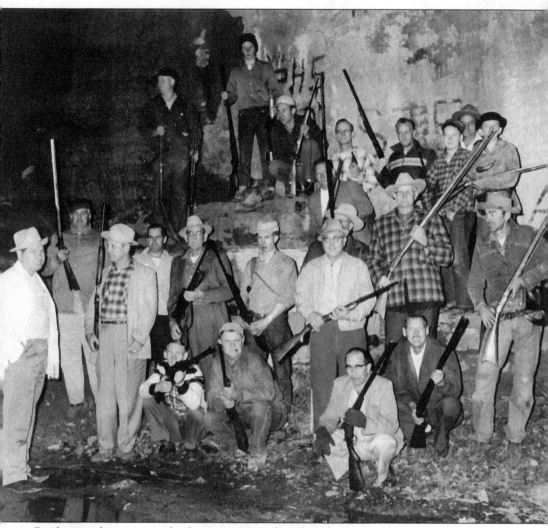

Border patrol men were a fun-loving, wise-cracking bunch who enjoyed appearing on the news. From left to right are (first row) Lloyd Sumner, William Kerry, Joseph Kelso, and Herman Logan; (second row) Zeke McGowan, Richard Easter, Fred Cartwright, William Custard, Jude Stevens, Gary Phipps, Louis Moneymaker, unidentified, Paul Henson, and James Stevens; (third row) James Riley, Eldon Riley, Charles Todd, Olin Ritter, Kenneth Headlee, Kim Kerry, two unidentified, and Skip Stevens. (Courtesy of Ralph Pogue.)

The rebellion was both interesting and funny. Secession memories hold onto a time when the innovative and thoughtful people of McDonald County put together a political protest that was effective beyond measure while providing an opportunity to have a good time. It was a good-natured "Don't mess with us" political statement. From left to right are Sgt. James Stevens, Lt. James "Squeak" Howerton, and Cpl. James Riley. (Courtesy of Ralph Pogue.)

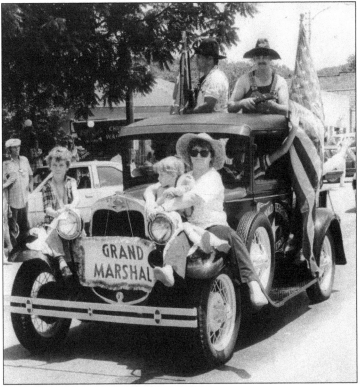

Parades are frequent and well attended in the small towns of McDonald County. Leading this 1987 parade is the official vehicle of the secession, a Ford Model A that belonged to James Stevens. It was later owned by his grandson Shawn Wilkerson. On the left are Ryan Howerton, grandson of Jim "Squeak" Howerton, and his grandmother Freida. Standing in the back are John Hunnicutt Jr. and Mark Harmon, sons of other original border guards.

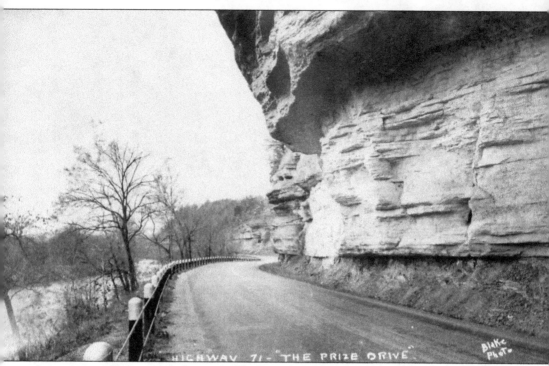

HIGHWAY 71 - "THE PRIZE DRIVE" Blake Photo

Amongst crystal-clear rivers, limestone bluffs, and picturesque back roads, the people here built motels, inns, cottages, and restaurants, creating great places for family vacations. Tourism continues to flourish in these wooded, rural Ozark hills and hollers.

Eight

WHEN HOLLYWOOD CAME TO THE OZARKS

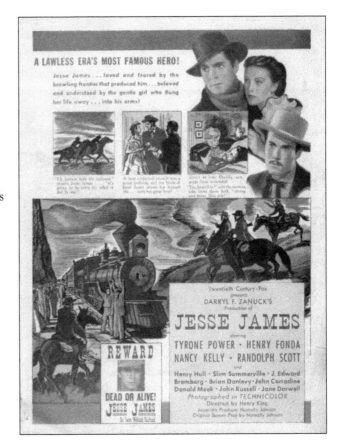

The summer of 1938 was an exciting time, as 20th Century Fox brought some of Hollywood's biggest stars, along with four baggage cars of equipment, to film the life of Jesse James. Much of the movie was filmed in Pineville, which was selected for its resemblance to post–Civil War Liberty, Missouri. Director Henry King told the chamber of commerce that the "scenery, and locality, and general surrounds of rivers, and natural things" attracted them. Thousands converged on Pineville, Noel, and Southwest City during the filming, bringing an economic boon.

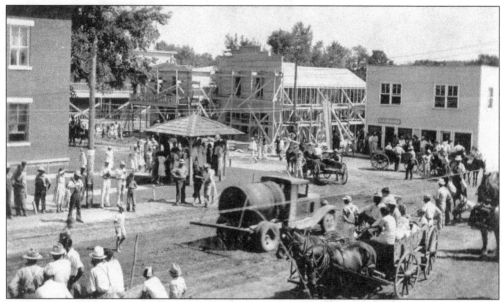

To create the appearance of post–Civil War Liberty, the Works Progress Administration's recently paved streets were covered with dirt. Wooden boardwalks covered concrete sidewalks, and wooden awnings, hitch rails, false storefronts, signs, a saloon, and a newspaper office were constructed.

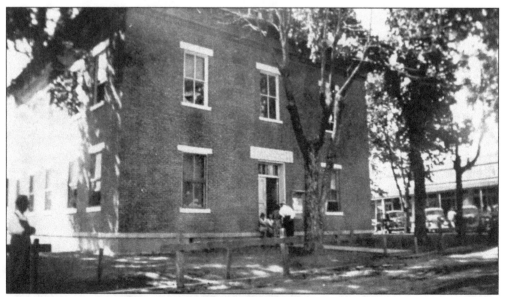

Resembling the original courthouse in Liberty, little construction work was necessary on the courthouse, although bars were placed in some of the windows to give the appearance of a jail. Hitch racks and water troughs were placed around the courthouse, and a well was built in the yard. (Courtesy of Mary Frances McGaw.)

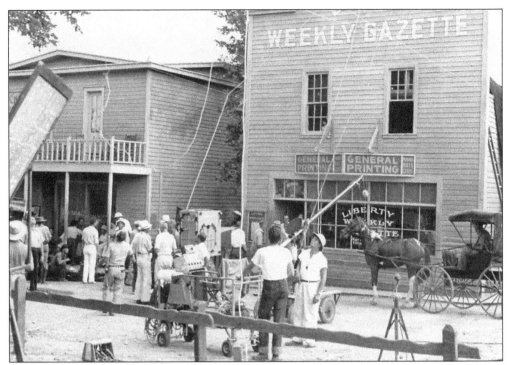

One of the newly constructed buildings was for the *Weekly Gazette*, the name of the Liberty newspaper. An old Washington hand press belonging to the *Pineville Herald* was installed along with other equipment seen in the printing shops of the time. (Courtesy of Mary Frances McGaw.)

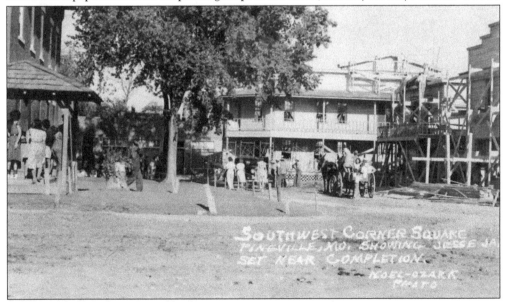

Pineville was transformed with the construction of false fronts on established buildings and new buildings constructed on vacant lots. The square now had a US marshal's office, the Dixie Belle Saloon and Hotel, a blacksmith shop, and the *Weekly Gazette* newspaper office. Crews of linemen rerouted electric and telephone lines. The Dixie Belle was converted to a movie theater, later sold and moved to Bunker Hill, where it was a dance hall. After being there for a few years, it burned.

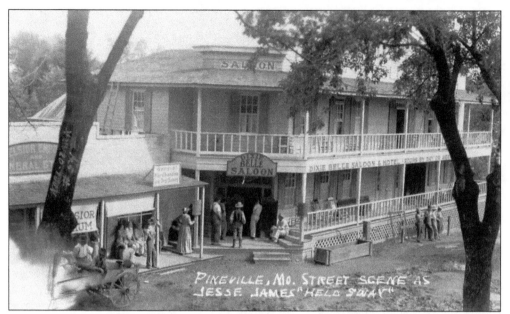

The Pineville square was transformed with the construction of the Dixie Belle Saloon and Hotel on the east side of the square. The Dixie Belle remained a part of Pineville for several years after the movie crews and tourists left. This photograph was taken from the southeast corner of the second floor of the courthouse.

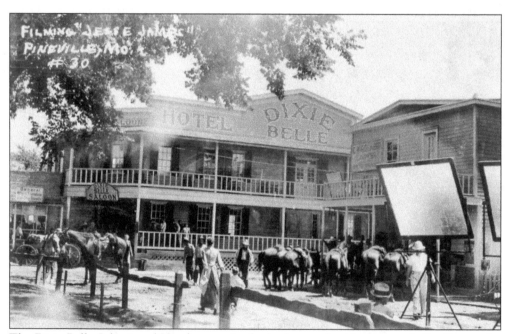

The Dixie Belle Saloon and Hotel towers in the background, with the marshal's office to the right. This was how the southeast corner of the square appeared in the movie. Both buildings were constructed by the movie crews. Men, women, children, horses, and the production crew came together to begin filming on the square in Pineville.

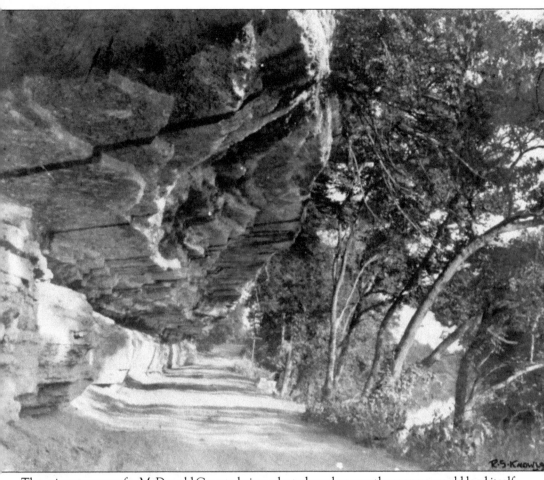

The primary reason for McDonald County being selected was because the scenery would lend itself better to Technicolor treatment. It was the first Technicolor movie filmed on location. Timbered hills, bluffs along winding streams, the 1800s courthouse, and several large caves all contributed to the county being chosen as the location for the film. A town could have been built, but it was the countryside that was carefully selected for this film. *Jesse James* probably would have gained more attention had it not been released the same year as *The Wizard of Oz* and *Gone with the Wind*. (Courtesy of Tammy Clark and Richard Davis.)

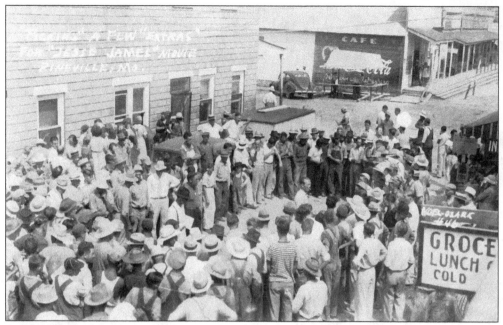

Several hundred local people were chosen as extras, with registration set up at the Drumm building. Individuals were paid for using their wagons, buggies, surreys, and horses. Pay was $1 a day for a horse, 50¢ for a vehicle, and $2.50 for the driver. A driver could make $5 a day, and have fun doing it.

Some of the extras were, from left to right, Al York, Minnie Bradley, T.O. Bradley, Flossie Bradley, Bonnibel Sweet, Helen Shinn, and Lucille Allman. Hundreds of others were chosen as extras to appear in group scenes. Costumes were supplied by the film company.

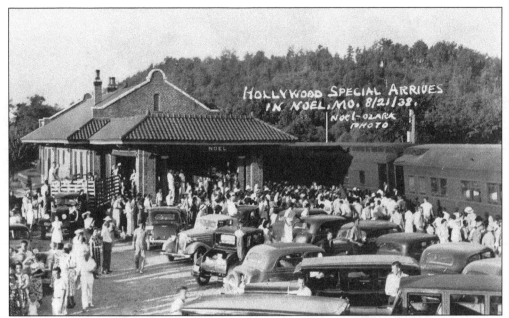

More than 150 cast members and technicians traveled on a special train from Hollywood to Noel for the filming. Many excited residents spent the night on the lawn near the Noel depot awaiting the arrival of the train, hoping to catch a glimpse of the movie stars. The train included 12 cars containing equipment and cast members. (Courtesy of Linda Martin.)

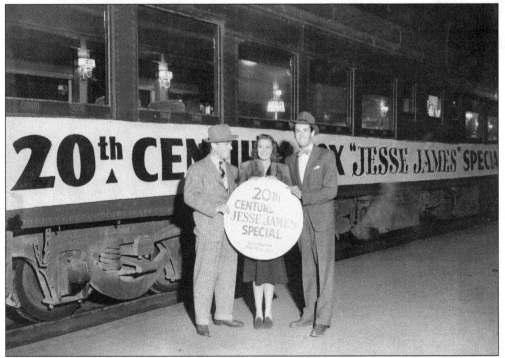

To the delight of the crowd, stars Nancy Kelly and Henry Fonda (right), playing Frank James, arrive on the "20th Century Jesse James Special." Heartthrob Tyrone Power, playing the lead role, arrived several days before. He and director Henry King flew into Joplin and drove down to Noel.

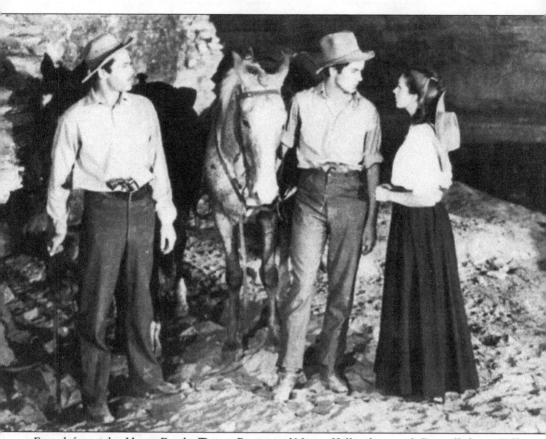

From left to right, Henry Fonda, Tyrone Power, and Nancy Kelly, along with Pineville horse Sally, prepare for filming at Salt Peter Cave near Craig O'Lea Resort. Carl Mayfield of Anderson was awarded the contract to furnish approximately 100 horses. The only horses used besides those furnished by Mayfield were a few trick horses brought from Hollywood.

Nancy Kelly appears relaxed while getting her hair done before filming the wedding scene at the Mill Creek Church. Dorothy Ann Elliff of Pineville was cast as Kelly's stand-in for the film.

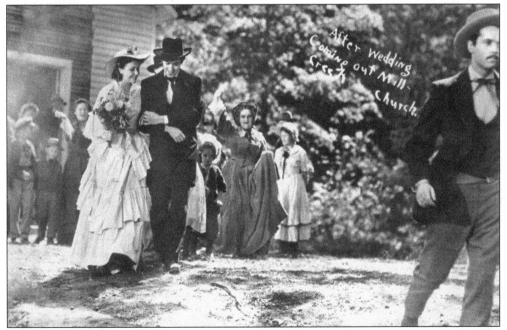

The Mill Creek Church east of Noel was used as the scene for Jesse and Zee's wedding. Locals cast as extras in this scene were Frank and Lenora Blankenship, Minnie Bradley, Teddy Jean Fenton, Beverly McCracken, and Doris Jean Goodnight. The church was used for exterior shots only. The interior filming for the wedding was done in Hollywood.

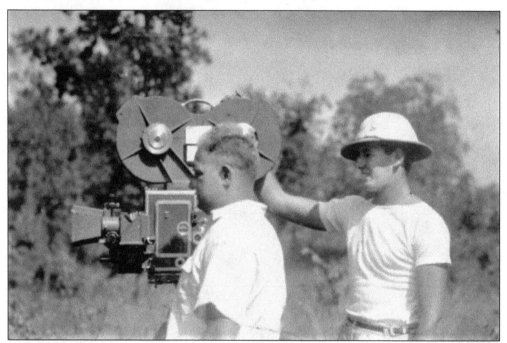

Filmed in Technicolor, a tremendous amount of equipment was necessary, including cameras, lights, and reflectors. There were about 60 operators working on the lights and cameras in addition to helpers hired locally. Here, Technicolor specialists Callahan and Harris operate a Graflex camera.

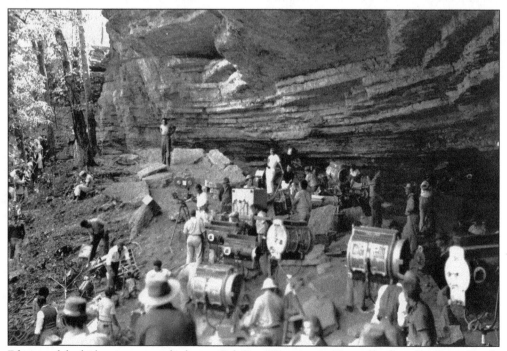

Filming of the hideout scene took place at Salt Peter Cave east of Pineville along Big Sugar Creek. As with the other filming locations, the cave became a popular tourist destination during and after filming.

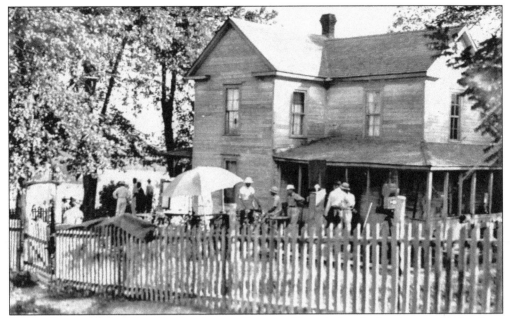

While filming at the Crowder farmhouse, Florence Crowder's prized guineas raised quite a commotion, interfering with the sound recording. Knowing they could not be silenced, director Henry King hired 10 boys to gather up the hens. Florence Crowder was paid 35¢ for each one of the 250 noisy birds. The movie crew was later served "Ozark quail" for supper.

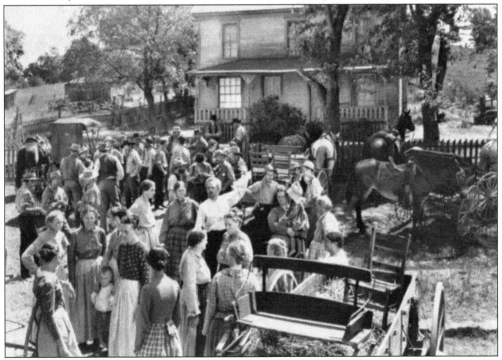

Florence Crowder was reportedly paid $3,000 to use her farmhouse, between Pineville and Noel, to stand in for the James home. That brought fame, along with thousands of visitors who trampled the farm. Many locals worked as extras, including members of the Crowder family.

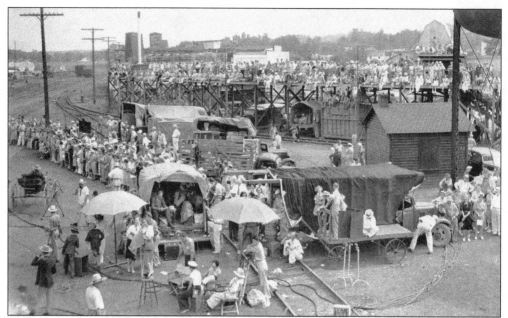

The Southwest City train depot stood in for the station in Liberty. Thousands gathered to watch the filming of the train robbery scene. Tyrone Power and Henry Fonda thrilled the crowd by appearing cheerfully on top of one of the train cars. Power wrote in his diary, "I never will forget the thrill of standing atop the coal tender with two big single action 45s in my hand while the old-fashioned train shook, swayed and rumbled down the track all the while the Technicolor camera was recording the scene."

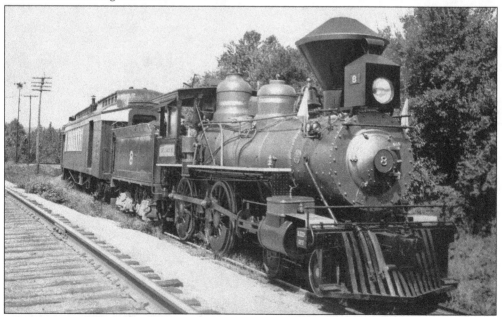

Historic engine No. 8 of the Dardanelle & Russellville (Arkansas) Railroad was restored to be used in the train robbery scene. The locomotive was taken to Little Rock to be painted and equipped with new flues and a smokestack. After filming was completed, the engine pulled back to the station in Southwest City and was retired to Arkansas. (Courtesy of Patty Lou Wilson.)

THE MCDONALD COUNTY HISTORICAL SOCIETY

The McDonald County Historical Society is a 501(c)(3) public charity completely funded by private donations. Its mission is collecting, preserving, and celebrating the rich and unique history of McDonald County. Since it was established in 1963, over 8,000 photographs have been donated to the society from county residents. Today, the society owns and operates three historic buildings, including a large museum in the old courthouse open to the public with free admission, and this historic sheriff's home just off the square in Pineville. There are no paid employees. A 15-member board works with over 80 volunteers supported and inspired by 225 members. (Courtesy of Ric Akehurst.)

McDonald County Historical Society
PO Box 572, Pineville, MO 64856

Courthouse Museum
400 North Main Street, Pineville, MO 64856

417-223-7700
mcdonaldcohistory@olemac.net
www.mcdonaldcountyhistory.org
Facebook: McDonald County Historical Society

Visit us at
arcadiapublishing.com

CPSIA information can be obtained
at www.ICGtesting.com
Printed in the USA
BVHW052132301121
622870BV00002B/151